THE DICKEYVILLE GROTTO

Also in this series

Americana Crafted: Jehu Camper, Delaware Whittler by Robert D. Bethke

Birds in Wood: The Carvings of Andrew Zergenyi by Melissa Ladenheim

Chainsaw Sculptor: The Art of J. Chester "Skip" Armstrong by Sharon R. Sherman

Chicano Graffiti and Murals: The Neighborhood Art of Peter Quezada by Sojin Kim

Earl's Art Shop: Building Art with Earl Simmons by Stephen Flinn Young and D. C. Young

The Holiday Yards of Florencio Morales: "El Hombre de las Banderas" by Amy V. Kitchener

Home Is Where the Dog Is: Art in the Back Yard by Karen E. Burgess

Punk and Neo-Tribal Body Art by Daniel Wojcik

Rubber Soul: Rubber Stamps and Correspondence Art by Sandra Mizumoto Posey

Santería Garments and Altars: Speaking without a Voice by Ysamur Flores-Peña and Roberta J. Evanchuk

Sew to Speak: The Fabric Art of Mary Milne by Linda Pershing

Star Trek Fans and Costume Art by Heather R. Joseph-Witham

Vietnam Remembered: The Folk Art of Marine Combat Veteran Michael D. Cousino, Sr. by Varick A. Chittenden

Folk Art and Artists Series
Michael Owen Jones
General Editor

Books in this series focus on the work of informally trained or self-taught artists rooted in regional, occupational, ethnic, racial, or gender-specific traditions. Authors explore the influence of artists' experiences and aesthetic values upon the art they create, the process of creation, and the cultural traditions that served as inspiration or personal resource. The wide range of art forms featured in this series reveals the importance of aesthetic expression in our daily lives and gives striking testimony to the richness and vitality of art and tradition in the modern world.

THE DICKEYVILLE GROTTO

The Vision of Father Mathias Wernerus

Susan A. Niles

University Press of Mississippi Jackson

Dedicated to sister folklorists Jan Roush and Susan Allen Ford and to Holly Carver and Lynda Leidiger, grotto enthusiasts

Photo credits: photographs of Mathias Wernerus and of Mary and Caroline Wernerus are reproduced by permission of the Dickeyville Grotto. All other photographs are by the author.

00 99 98 97 4 3 2 1

Library of Congress Cataloging-in-Publication Data

Niles, Susan A.
 The Dickeyville grotto : the vision of Father Mathias Wernerus / Susan A. Niles
 p. cm.—(Folk art and artists series)
 Includes bibliographical references.
 ISBN 0-87805-995-4 (cloth : alk. paper).—
ISBN 0-87805-996-2 (pbk. : alk. paper)
 1. Wernerus, Mathias, Father—Criticism and interpretation. 2. Outsider art—Wisconsin—Dickeyville. 3. Dickeyville (Wis.) I. Title. II. Series.
N6537.W365N55 1997
709´.2—DC21 96-37975
 CIP

British Library Cataloging-in-Publication data available

CONTENTS

In twenty years of studying Inca shrines and palaces, I often lamented the fact that identifying the work of individual architects was so difficult and interpreting their handiwork so frustrating. If only the Incas had had a tradition of writing! If only they had lived fifty years ago, rather than five hundred! In the early 1990s when I turned my attention to folk architecture in the United States, I looked forward to a research project where I wouldn't face such problems.

The grotto at Dickeyville, Wisconsin, built by Father Mathias Wernerus in the 1920s and 1930s, captured my attention; I was interested both as archaeologist and as folklorist. The strange constructions of concrete, studded with glass, broken ceramics, marbles, and even gearshift knobs, were classic examples of folk art. They grew from an iconography rooted in European Catholicism, but were the personal expressions of piety of an artist who rendered sacred symbols in unorthodox media. The works had the exuberance I had seen in folk Catholic art in Latin America but were growing here from a German-American identity.

Father Wernerus's work was well preserved and accessible. I fully expected that I could use parish records, newspaper morgues, and Father Wernerus's own writing to reconstruct his motivation. To my surprise, I discovered that documenting Father Wernerus's work wasn't much easier than identifying palaces commissioned by Inca kings. My project became a study of how we can reconstruct the patterns of work and the motivations of a folk artist who is no longer living.

Although he was an educated man and, as parish priest, subject to the bureaucratic requirements of his diocese, Father Wernerus left very little written record of his work. An illustrated pamphlet prepared around 1930 includes a short foreword by the priest and captions that he probably wrote; this is our only firsthand testimony. Although Father Wernerus knew how much money he owed for the grotto, he did not keep detailed records to indicate his sources for material or the way he organized work. His attitude about his role as an artist and builder can only be reconstructed indirectly: in a history of the parish he comments on the work of his predecessors, offering opinions about work, faith, and remembrance. A letter to his bishop shows Wernerus's worries about the enormity of the work of building and maintaining the grotto and his fears about the chilly reception of his work by other priests and—possibly—by the bishop himself.

Other information comes from documents that present the grotto to modern visitors. Brochures and souvenir booklets focus on the materials used and the Catholic symbols. Teenage parishioners selected to work as guides memorize a speech which orients the visitor to the chronology and iconography of the site. The official story presented in such forms has shaped the

narrative that parishioners remember and retell when they talk about the grotto. Like most official histories, it tells only part of the story.

Two pieces of the story are especially significant in their absence: Father Wernerus's sources of inspiration for the grotto and his plans for its disposition. I found people in Dickeyville who had visited the Grotto of the Redemption in West Bend, Iowa, which was almost certainly the source of some of Wernerus's ideas. The literature that orients visitors to the site makes no mention of this or of any other midwestern grottos that may be relevant to the diffusion of the art form. I found no one in Dickeyville who was aware of the correspondence between Father Wernerus and Bishop McGavick over the fate of the grotto or the priest's scheme to secede from the diocese. There are no copies of their letters in parish archives, and, if anyone ever knew the story, it was not passed along and has vanished from public memory.

In presenting my own narrative about Mathias Wernerus's work as a folk artist, I distinguish among the sources that I used. When I report that "visitors are told. . . ," I am relying on literature distributed at the site or on the text of the speech used by guides. In my interpretation of Father Wernerus's work I refer to the Douay-Rheims version of the Catholic Bible, the version most likely to have been used by midwestern Catholics during the priest's lifetime.

A number of people in Dickeyville offered me help and friendly conversation. I am especially grateful to Rev. James Gunn, current priest of Holy Ghost Parish, and Rev. Frances J. Steffen, its former priest, for opening parish archives to me. Marge Timmerman, manager of the grotto, was helpful, as were the site guides and staff of the grotto gift shop. Esther Berning and Henrietta Hauber kindly shared their remembrances of the grotto with me in person, and Hank Melssen spoke to me on the phone. Rev. Michael Joseph Gorman at the diocesan archives in La Crosse gave me access to material on Father Wernerus. Msgr. Edgar Kurt of the archdiocesan archives at Dubuque discussed Iowa grottos with me. Sister JoAnne at St. Rose Convent in La Crosse shared files on the work of Father Paul Dobberstein. Brigitte Burkett transcribed and translated Mathias Wernerus's 1904 correspondence.

Jan Roush and Susan Allen Ford visited Dickeyville with me and encouraged me in this project. Holly Carver, Mike Chibnik, and Lynda Leidiger provided hospitality and enthusiasm in Iowa City. Anne Paul generously read a draft of this manuscript. My students Jeffrey B. Holton and Brenda Toma kept me on track with questions, as did anthropologists Jill Dubisch, Larry Taylor, and John Napora and folklorist Bob Walls. Lafayette College, through its Committee on Advanced Study and Research, provided support for my study of midwestern grottos.

On June 8, 1872, a group of German-speaking Catholics met at the town hall in Dickeyville, Wisconsin, to put into motion their plan to organize a parish. At about the same time, Mathias Hubert Wernerus was born back in the old country. Half a century later, Wernerus would ask the parishioners of Holy Ghost Congregation to help him build a monument to his faith and to the country they had all chosen as their home. This work would become one of the most important folk art environments in the United States, a testament to the imagination and technical abilities of a little-known folk artist.

Father Wernerus's works are built in the open area between the Holy Ghost Church and the priest's house and in the cemetery behind the church. The site consists of two major groups: the Grotto of Christ the King and Mary His Mother, and the Patriotism Shrine. In addition, the park between these two groups and the church has a number of small works in carefully tended lawn and garden patches set apart by paths and decorated fencing. Behind the church is another major construction, the Shrine of the Sacred Heart. Flanking the entrance to the church is a pair of decorative flower pots. The cemetery behind the church has two works: the Crucifixion Group, which includes decorated flower vases, and the freestanding shrine of the Holy Eucharist, found in the northeast corner of the cemetery grounds. Pairs of decorative posts also mark the entrance to the priest's house and to the cemetery driveway.

This is how the site appears now. But it is important to explore how the priest and the parish came together to develop this extraordinary monument to religion and patriotism.

The Artist

Mathias Wernerus was born on September 10, 1873, in the town of Kettenis, now in the German-speaking part of Belgium. He was baptized the same day by the priest at the local parish of St. Katherine. His father, Christian Joseph Wernerus, was a baker, and died while Mathias was still young, probably in the late 1880s. His mother, Katherina Liebertz Wernerus, was still alive and living in Aachen (German Rhineland) in 1904, along with an unmarried daughter and a son who worked in the postal service. Two other sons were married, and the other daughter was in a cloister.

Our knowledge of Mathias's youth is based on documents he presented when he wished to emigrate to America and enter a seminary there. He was confirmed on September 8, 1886, in Eynatten, and attended Catholic school from the age of six until he was fourteen. The family's fortunes changed at the death of his father, however, and Mathias left school to follow his

father's trade, work he continued until he was twenty years old. At that point, he carried out two years of obligatory military service. After his discharge in 1895, he returned briefly to work as a baker before resuming his studies. On September 2, 1897, he was admitted to a Salesian school in Liege, Belgium. After three years, he was sent to the novitiate where he studied philosophy for two years, and, having decided to defer entrance to the order, went to teach in a Salesian secondary school in Muri, in German Switzerland. By this time he spoke French as proficiently as he did his mother tongue, German. After two years at Muri his superiors asked him to return to Brussels to continue the study of theology. But this was not what Mathias wanted to do. He spent at least a year trying to convince them that he wanted to emigrate to North America to become a priest. In May 1904, Mathias wrote to the director of St. Francis Seminary in Milwaukee, Wisconsin, seeking admission. Although he did not at that time speak English, the seminary was soliciting applications from German-speaking boys who wanted to work in immigrant parishes in the Midwest (Greving 1993:2). Mathias's acceptance by the seminary was swift, and in July of 1904 he wrote to express his joy. On March 5, 1907, he was sworn to service in the Diocese of La Crosse (Wisconsin); on June 23 of that year he was ordained as a priest. He returned home to Germany to celebrate his first mass at St. Paul Church, Aachen.

In September 1907 he began the first of a series of positions within the diocese of La Crosse, serving briefly in several small towns (the Church of the Nativity of the Blessed Virgin in Keyesville; St. Joseph's in Fairview; Holy Rosary parish in Lima; St. Andrew's in Rozellville). On April 10, 1918, he moved to Holy Ghost parish in Dickeyville, where he would serve as parish priest until his death in February 1931.

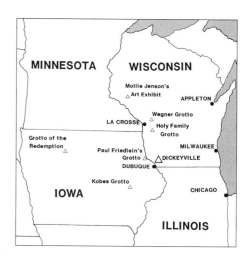

Map showing the location of sites mentioned in the text.

The Parish

The parish in which Father Wernerus served was formed in 1872 by forty-five pioneer families. Like many of the small communities on the banks of the upper Mississippi River, Dickeyville had been settled by German-speaking immigrants. The town itself was small—its population was twenty-four in 1870, and fewer than a hundred in 1877—and the parish comprised mainly farmers from the surrounding region. The establishment of their own congregation—along with a building to house it—was a bootstrap operation. The

8

original founding families designed and built a small church, contributing labor to that project at the end of harvest. The first services were held in the new church building in June of 1873.

The priests who served the parish in its early years were much like Father Wernerus: all were of German descent, many having been born in Europe, and most had been trained at St. Francis Seminary in Milwaukee. All were interested in building up the parish—quite literally.

A brief history of the parish from 1872 to 1920 written by Father Wernerus (Wernerus 1920a) is a standard history of a pioneer church and its dedicated priests. It is also our best insight into Mathias Wernerus's view of himself and his parish. By reading his account of the works of his predecessors, we see the concerns that motivated him in his own work.

His narrative stresses the tangible improvements each of his predecessors made to the parish: Rev. Halbenkamm oversaw the building of a ceiling for the church, Rev. Raess imported an oil painting from Munich, Rev. Ollig acquired a furnace, and Rev. Fisher improved the church interior and the priest house. His immediate predecessor, Rev. Charles Rumpelhardt, directed the construction of a new and much larger church, which was dedicated in 1913.

In his history, Father Wernerus was placing himself in the tradition of the builder-priest, and showing the importance of the priest working with the parish to improve its property. The history also shows other of his interests.

Father Wernerus was very concerned with commemorating events and with remembering the dead. He reports that one of his predecessors, Rev. Fisher, who died in office, was not buried in Dickeyville, due to the request of his brother that he join the family plot. Wernerus interrupts his recounting of the facts to editorialize:

Permit me to state here that I fully believe that on that occasion the people of Dickeyville made a great mistake by permitting the relatives to remove the body of their good priest. No doubt they should have insisted to keep their spiritual father and friend and to bury him on their own graveyard. . . . Just think how many prayers would have been said and would be said in the future were he buried here! But here, unfortunately, the old adage is verified: "Out of sight, out of mind." You certainly would have rendered the greatest service to poor Father Fisher's soul, if at that time you would have protested solemnly and vigorously against the removal of the body of your beloved priest. (Wernerus 1920a)

Wernerus expected parishioners to demonstrate their faith by their participation in activities directed toward the

common good. Those who shirked their responsibility to the congregation were showing disrespect to the parish, the priest, and the deity. Wernerus reports that his predecessors had relied on members of the congregation to outfit the church and its holdings. In some cases, the members gave money to acquire objects for the church or the school; in others, they gave work to add to the church's holdings. Wernerus praises the work and gifts of the parishioners. He also notes, disapprovingly, the failure of some members to live up to their duties to other congregants, characterizing such people as "slackers" (Wernerus 1920a).

The Works

Father Wernerus approached his post with enthusiasm and plans to improve the parish. Initially he directed his energies to traditional works. As soon as he arrived in the spring of 1918, he asked the congregation to begin work on a new school. Although he acknowledged his predecessor Father Rumpelhardt's reputation as a "clerical hustler" (Wernerus 1920a), he personally collected pledges and donations for the project (*Commemorating a Century of Growth:* 28). By May he had organized a committee for the project, and the school, along with a new house for the teaching nuns, was completed in 1919. The declaration of the end of World War I in November 1918 inspired Father Wernerus to his first commemorative works. He asked the congregation to contribute toward the purchase of a bell to mark the end of the war. Their generosity permitted the parish to acquire two bells, rather than one; the old bell was retuned to accord with the new ones and with a recently purchased school bell. The peace bell was inscribed: "In the year of Our Lord, 1919, Mathias Wernerus, pastor of this congregation, caused me to be cast as a memorial to the end of the war."

The Crucifixion Group. The end of the war was also recognized in the creation of the Crucifixion Group and Soldiers' Memorial, which was under construction in 1920. Father Wernerus directed his energies to clearing trees from the cemetery and reorganizing the space. His plan included a fence and gate, landscaping, and a lane directed to the Crucifixion Group. This latter includes a terraced mound, surmounted by steps, with larger-than-life-sized marble statues of Mary and the disciple John at the base of a cross bearing the crucified Jesus (plate 1). Tilework at the base of the crucifix frames a bronze plaque dedicating the monument to Albert Riemenapp, Michael Loeffelholtz, and Michael Jenamann, three young men of the parish who died in the war. The priest wrote that the Crucifixion Group would serve as "a constant reminder never to

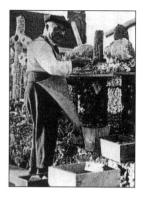

Photograph of Mathias Wernerus working on the Patriotism Shrine, ca. 1930.

forget the good boys in our prayers" (Wernerus 1920b). The statues were purchased from the Munich Statue & Altar Company of Milwaukee. The construction of the group was done by George Kuwalski, parishioner and contractor.

The purchase of the bells and the work on the Soldiers' Memorial and Crucifixion Group are not, of themselves, evidence of Mathias Wernerus's work as an original folk artist. But they do show his interest in giving material form to emotions and memories. The cemetery would be the site of his first efforts at construction in concrete and other media.

The original budget for the project includes purchase of iron and wire flower vases from the Badger Wire & Iron Works. At some point—either in 1920 when the group was erected or later when he began his serious work in the medium—Father Wernerus constructed concrete flower vases, which, studded with glass and stone, depict flowers emerging from pedestal vases with wing-like handles (plate 2). Parish tradition asserts that these vases were his first works and the place where he developed a technique he would use in his more ambitious constructions.

Eucharistic Altar. In the fall of 1924 ("The Grotto at Dickeyville") Father Wernerus began work on a small, freestanding structure in the northeastern corner of the cemetery. The Grotto of the Holy Eu-

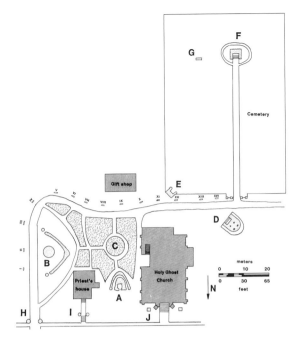

charist is a small, open-fronted structure covered with a domed roof (plate 3). The front includes two column-shaped supports that flank the highly decorated interior space. This interior includes a niched altar. The elaborate iconography of the interior works out symbols of the Eucharist: semi-precious stones form an arch of grape bunches that stand for the wine; inlaid tiles work out the sheaves of wheat (plate 4). A legend in shiny silver and gold colored tiles spells out COME LET US ADORE. Shells, tile, and glass rosettes cover the rest of the visible surface of the interior (plate 5). The exterior walls are covered with a whitish quartzite, with many shells on the roof, and with shards of green and red glass forming diagonal bands on the false columns. The

Plan of Dickeyville Grotto. A, Grotto of Christ the King and Mary, His Mother; B, Patriotism Shrine; C, grotto parks and gardens; D, Grotto of the Sacred Heart; E, Grotto of the Holy Eucharist; F, Crucifixion Group and Soldiers' Memorial; G, Father Wernerus's grave; H, entry to Holy Ghost Park; I, entry to priest's house; J, decorative flower pots; I–XIV, Stations of the Cross.

11

grotto includes all the techniques that Father Wernerus would use on his more ambitious compositions: concrete formed into slabs; all visible surfaces covered with shiny material; bits of things worked into representations of other objects. Still, it is clear that he had not yet refined his technique: the joins of the concrete slabs are visible, the stripes on the columns do not have clearly defined edges, and the roof appears to be a jumble of randomly placed material.

Grotto of Christ the King and Mary, His Mother.

In the fall of 1924 Father Wernerus began to plan a more ambitious work. The immediate inspiration for the plan was the promise of a gift of another marble statue, one depicting Mary holding an infant Jesus in her arms. The source of the gift is the subject of varying stories. Some assert that an unnamed friend of the priest vowed to provide the statue if he was cured of an illness. Others do not mention the illness or miraculous cure. One source, Art Wiederhold, identified the donor as Joe Baul, a grocer from Dubuque ("Villagers Recall Work"). The priest probably planned a more humble grotto to house the statue than, in fact, he built. One newspaper reported that he had planned to build a second Eucharistic altar ("The Grotto at Dickeyville"). However it began, in 1925 Mathias Wernerus started work on the composition that would be the centerpiece of his project: the Grotto

of Christ the King and Mary, His Mother.

This complex composition is composed of two main parts: a roofed structure (the grotto proper) housing the statue of Virgin and Child, and an open-air walkway (or ambulatory) behind the grotto structure. The ambulatory includes niches which house statues of an adult Jesus and the apostles. The interior and exterior surfaces of the grotto building are elaborately decorated with inset designs. The niched wall is decorated only on the surface that faces toward the grotto building.

The grotto structure is approximately sixteen feet by thirty feet in area and about twenty-five feet high. The loaf-shaped building has an arched, open doorway on one of the short ends (plate 6), while its rear end rises to a curved peak. The front façade includes a false Roman arch that defines the portal and displays mosaic rosaries (plate 7). Visitors are told that the colors of the rosaries (yellow, red, and green) stand for the three mysteries of meditation—respectively, the joyous, sorrowful, and glorious mysteries (*Grotto and*

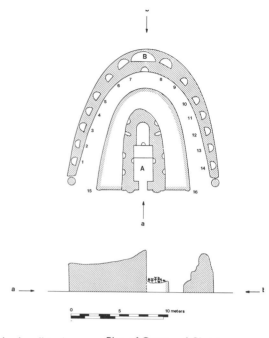

Plan of Grotto of Christ the King and Mary, His Mother. A, Grotto of the Blessed Virgin; B, statue of Christ the King; 1, St. Simon; 2, St. James Minor; 3, St. Bartholomew; 4, St. Thomas; 5, St. Andrew; 6, St. Peter; 7, St. Joseph; 8, St. John; 9, St. Paul; 10, St. Matthew; 11, St. James; 12, St. Thaddeus; 13, St. Philip; 14, St. Martin; 15, Vatican flag; 16, American flag.

12

Shrines). The entryway also includes panels indicating the dates of its construction: 1925 (to the left of the door) through 1929 (to the right) (plate 8). Flanking the front wall are a pair of poles that support flags worked in cement and glass, with legends below them spelled out in children's marbles. To the left is a Vatican flag over the legend RELIGION (plate 9); to the right is an American flag and the legend PATRIOTISM (plate 10). This composition helps to orient the viewer to the theme of the site as a whole.

The interior of the grotto includes an overwhelming display of objects and mosaics. The statue of the Virgin and Child is centered in the rear wall in an arched niche with a bright blue background and white stars (plate 11). The statue is raised above a nearly waist-high altar so that the visitor's eyes will be near the level of the feet of the Virgin, though the feet themselves are obscured by a mass of multicolored glass roses. More roses decorate a pair of columns that flank the statue and the arch that defines its niche.

The walls of this interior space spell out the dedication in banners at the height of the Virgin's head: on the left, TO JESUS THE SAVIOR, ALL GLORY AND PRAISE; to the right, TO MARY HIS MOTHER, ALL HONOR AND LOVE. The walls are further decorated with inset designs depicting symbols important in Catholic belief and ritual. On the left side, moving from front to back, the wall spells out the theological virtues in the colors appropriate to Catholic iconography: FAITH (blue), HOPE (green), LOVE (red) (plate 12). It also includes a decorated missal. A stole and chalice represent the priest and mass (plate 13); a cross with ladder and hammer is included as the symbol of the Passion of Jesus (plate 14). Crossed keys rendered in gold-colored tile depict the keys of heaven (Wernerus ca. 1930) or the founding of the church (*Grotto and Shrines*). On the right wall is an Old Testament image of the Ten Commandments, its stone tablets rendered here in glass tile, and a New Testament image of loaves and fishes.

While it is possible to recognize the images described above in the glass- and stone-studded wall of the grotto, they are nearly obscured by a profusion of decorations—shells, fossils, glass flowers—covering all visible surfaces. Stalactites and stalagmites, too, appear in the grotto's interior, perhaps as visual referents to the origin of the term "grotto," meaning cave. The veined marble altar at the feet of the statue of Virgin and Child disappears into a mound of items—some, perhaps, referring to religious mysteries, and others just mysterious. Marble statues of kneeling angels are placed at each side of the altar along with a balanced composition of candlesticks. Two small crucifixes, one above the other, are centered on the altar. One is said to have been carved by an Indian convert of the

French priest Father Marquette, traditionally considered one of the founding European fathers of Wisconsin. The altar also holds arrangements of small ceramic figurines, where swans and horses, geishas and gauchos compete for the viewer's attention. The meaning of this display is not explained to visitors.

The use of decorated wall surfaces to depict a rich iconography continues on the grotto's exterior (plate 15). The side and curved rear wall of the grotto are covered in fairly large pieces of a grayish stone, set with no attempt at coursing, over most of the surface. Niches (three on each side) are set into the wall (plate 16). They are dedicated to six of the seven gifts of the Holy Spirit. Moving clockwise from left front, they show: FEAR OF THE LORD, PIETY, KNOWLEDGE, COUNSEL, UNDERSTANDING, and WISDOM. Above these niches, small windows pierce the wall to provide some light to the rear of the grotto's interior (plate 17). The rear wall of the grotto includes a composition called the Tree of Life or the Holy Ghost Tree, its trunk and lower branches formed of huge pieces of petrified wood (plate 18). The upper branches and fruits are worked in colored glass. At the top of the tree is a tile mosaic depicting an upturned dove, representing the Holy Ghost, and above it, the word FORTITUDE (the seventh gift of the Holy Spirit). Adjacent to the tree branches

is a listing of the twelve fruits of the Holy Spirit: FAITH, PEACE, CHASTITY, MILDNESS, LONG SUFFERING, PATIENCE, JOY, CHARITY, GOODNESS, BENIGNITY, CONTINENCY, and MODESTY.

Following the curve of the grotto's side and rear walls is a terraced planting bed which gives color to the base of the Holy Ghost Tree. A concrete walkway similarly follows this curve, permitting visitors to see the niched wall that faces the grotto structure (plate 19). This wall is composed of larger gray rocks that outline arched niches lined with colorful glass and displaying white marble statues (plate 20). The wall rises to a large, central niche that houses a statue of an adult Jesus (plate 21). The smaller niches depict the apostles, St. Paul, and Joseph, earthly father of Jesus. Moving clockwise from the left front wall, the images include: ST. SIMON, ST. JAMES MINOR, ST. BARTHOLOMEW, ST. THOMAS, ST. ANDREW, ST. PETER, ST. JOSEPH, JESUS, ST. JOHN, ST. PAUL, ST. MATTHEW, ST. JAMES, ST. THADDEUS, ST. PHILIP, and ST. MATHIAS. The interior of each niche is covered with colored glass. The small statues are identically labeled with plaques: ST. ___ PRAY FOR US.

The central image of Jesus has more elaborate decoration. At its feet, tiles spell out: JESUS CHRIST KING OF HEAVEN AND EARTH. The king metaphor is made tangible in Jesus' gold-colored crown, the

scepter in his right hand, and the volleyball-sized earth held in the left hand. Jesus stands on a pile of glass roses, and two marble lambs are at his feet. Below the legend is a small glass-covered niche with ceramic figurines depicting the nativity.

The Patriotism Shrine. The next major group that Father Wernerus built was the Patriotism Shrine. Like the Christ the King walkway, this group includes an open curved wall that rises from the ends to the center; marble statues and other imagery are again displayed to the interior of the curve (plate 22). The central figure is Christopher Columbus, who is depicted with a ship's wheel (plate 23). He stands under an arch set with light blue glass and seventy wild roses which commemorate the seventy days he spent at sea (Wernerus ca. 1930). The arch and its base are further decorated with conch and abalone shells and figurines with a nautical motif (plate 24). Tilework beneath the statue has the legend CHRISTOPHER COLUMBUS DISCOVERER OF AMERICA 1492 above a juxtaposed cross and anchor. In Catholic imagery, the cross depicts faith and the anchor hope. At each end of the curved wall is a pedestal with a standing marble statue; to the left is a statue of George Washington, and to the right is Abraham Lincoln. The top of the wall also supports rosette-encrusted anchors (plate 25), and, at each end, a tile- and glass-studded bell (plate 26).

The bell closest to Washington is labeled LIBERTY 1776. The bell near Lincoln is labeled UNITY 1865. Centered in the curved plaza is a tiered fountain surmounted by an eagle, representing the government of the United States (plate 27). As with the religious grotto, the Patriotism Shrine incorporates objects donated by visitors. Visitors are told that it includes arrowheads and axes brought by Indians from the Keshena reservation (*Grotto and Shrines*).

Other Groups. While the two major groups were under construction, Father Wernerus designed and completed the rest of the works at the site. A freestanding shrine to the Sacred Heart of Jesus was built between the church and the cemetery in the 1929–1930 season ("The Grotto at Dickeyville"). Two tiers of stone-faced planting terraces support an oversize painted statue of an adult Jesus, standing on a globe with arms reaching forward, and with a conspicuous heart atop his clothes (plate 28). An elaborate domed roof supported by four columns shields the statue. Like the columns of the Holy Eucharist grotto, these are decorated with diagonal

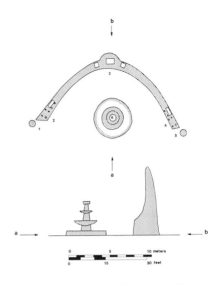

Plan of Patriotism Shrine. 1, George Washington; 2, Liberty Bell; 3, Christopher Columbus; 4, Unity Bell; 5, Abraham Lincoln; 6, eagle fountain.

15

bands of glass. The top of the dome has a cross. A triangular panel in the entablature depicts an isolated Sacred Heart. A legend around the architrave spells out: BLESS US OH SACRED HEART NOW AND FOREVER. Visitors may approach the shrine and climb a few steps up to a niche near the base of the statue. The source of inspiration for this shrine is clear: it is a copy of an altar built for the Eucharistic Congress in Chicago in 1926. That altar, in turn, was a copy of the main altar of the church of St. Paul's Outside the Walls in Rome (Wernerus ca. 1930).

The grounds surrounding the church and its grottos were made into gardens and parks in 1928, 1929, and 1930 ("The Grotto at Dickeyville"). Fences covered with concrete and studded with glass, rock, and shell define an irregularly shaped lawn and planting beds (plate 29). A circular bed in the center is surrounded by heart-shaped elements studded with white shells. The park spaces enclose small statues set on decorated bases, decorative flower pots, and a concrete birdhouse. Some of the statues have a religious theme: a young girl holding a pitcher refers to the biblical story of Rebecca (plate 30); a glass-and-concrete well from which she drew the water is nearby (*Grotto and Shrines*). Other images seem purely secular: swans, animals, and children are disposed in arrangements reminiscent of the yard art of the Midwest. Of the parks, Father Wernerus wrote:

"The intention of the builder of all these beautiful things was, to the greater honor and glory of God and to make people happy and lead them to God" (Wernerus ca. 1930).

A final composition was built in 1930 ("The Grotto at Dickeyville"). Flanking the entrance to the church is a pair of decorative flower pots (plate 31). Each is a tile-covered cube supporting a hemispherical bowl. In each bowl is an arrangement of crystals, coral, and glass flowers set atop branches of petrified wood. The priest's house adjacent to the grotto also has modest decorations in Wernerus's style: two entry posts and a decorative plaque indicating the date of the construction of the house, 1930. There is, finally, a pair of decorative posts flanking the driveway that gives access to the cemetery and to the rear of Holy Ghost Park.

Artist and Helpers

We might think of a folk or outsider artist as working alone—shaped, to be sure, by the cultural environment, but creating a singular representation of his or her vision of the world. Mathias Wernerus is remembered by the parish as the artist

Photograph of Mary Wernerus (right) and Caroline Wernerus.

16

who single-handedly built the grotto. But there were many who helped the priest realize his vision.

Without doubt, Father Wernerus's most important assistant was his cousin, Marie (Mary) Wernerus. Twenty years older than Mathias, she came to Dickeyville to be his housekeeper, and, at some point, brought Caroline (Lina), her adopted sister, to help her in her work. Both women had been born in Europe; Marie had a heavy German accent and Lina spoke little English. The sisters were instrumental in the construction of the grotto. Esther Timmerman Berning, who was a schoolgirl when the grotto was being built, recalled that Marie was the artist who constructed flowers by setting bits of brightly colored glass upright into concrete. When she came to the door, according to Berning, her hands would be raw and red from working with the concrete, and her fingertips would be cut from sticking the bits of glass into it. Another parishioner, Barbara Melssen, confirmed her role: ". . . Marie, she made all the flowers in the grotto and she was 72 at the time" ("Villagers Recall Work").

In addition to her active work in the construction of the grotto, Marie provided considerable emotional and financial support to Mathias, who characterized her as "the best friend and dearest soul I had on earth." Her financial support is evidenced by Father Wernerus's claim that "the Deficit of 6095.15 belongs to me or rather to my cousin and to her adopted sister who at present is my housekeeper. These two ladies never received any wages for this faithful service. Of course I took care of their wants and will take care of the one that is with me now."

When Marie died in December of 1930, Mathias was devastated. He worried about continuing his work without her: "The thing already now is getting too big for me, my strength is going down. I am not the strong man anymore I used to be when I began this big thing. Formerly my cousin carried more than half of the work on her shoulders; now all rests on me. How long I be able to do it—I don't know" (letter to bishop, January 19, 1931).

Others who assisted Father Wernerus in his work were parishioners. Leo Melssen, a blacksmith, contributed the important work of shaping the iron that would be used as the support for the cement. Melssen's widow, Barbara, later told reporters that her husband initiated the construction and design of the grotto: "Fr. Wernerus came to the house one day and said 'I've got a statue and I want to build a grotto.' Leo said, 'Why not build a big one and make it worthwhile' so the two of them went to the garage. Leo got the chalk and the two of them drew out the design on the cement floor. Both of them came from the old country, from Holland and Germany, where there were so many grottoes" ("Villagers Recall Work"). Melssen shaped the

iron frames that Wernerus used in constructing his works. George Splinter was another parishioner who worked especially closely with Father Wernerus, rising early to start the work just after morning mass, and continuing until after dark ("Grounds Keeper for 20 Years").

Many other parishioners contributed work or material. The nature of the work varied with the age and expertise of the worker. Contractor and mason George Kowalski made forms. Others helped to mix concrete and haul loads of rock and fill. Some people were hired as workers to help finish the job.

In asking parishioners to fund the project and to help him with the work, Father Wernerus was following a practice used in previous building projects in the parish. Records of the construction of the church (overseen by Rev. Rumpelhardt and completed in 1913) and school (directed by Father Wernerus in 1918–1919) carefully indicate the amount of money pledged by each parishioner and the amount actually contributed; they also note the number of loads of materials carried, the number of teams of horses contributed, and the number of hours given to the project. Some of the people who had given the most labor to the church construction were among the early workers on Father Wernerus's grotto.

Father Wernerus also used students from the parochial school to help him with his work. Schoolchildren helped to dig the holes for the foundations ("Villagers Recall Work"). Henrietta Hauber and Hank Melssen recalled that girls were generally given the task of washing rocks and glass; Melssen reported that boys were asked to carry material. Esther Berning remembered that she sometimes worked indoors, helping Mary and Lina. Although the schoolgirls were not permitted to make the rosettes, they did help the older women set glass and stone in the concrete.

In addition to marshaling the work of parishioners and schoolchildren, Father Wernerus sought donations of money and objects to help him in his work. Esther Berning recalls that she had been given a dollar for her first communion. Although she worried that her mother would disapprove, she spent the dollar at a church raffle and won ten dollars. That was a lot of money in 1929, especially for a little girl from a struggling farm family. About the time she won the money, she heard Father Wernerus address the congregation to ask for contributions: "'Tell your parents I need three windows. If they want to give something, they are ten dollars apiece.' So I asked Mom could I give my ten dollars for the window. Before mass I walked up to Father, gave him my ten-dollar bill. He knew the circumstances of my family, and said, 'Don't forget—you've got a pull with the Blessed Mother—don't let her forget it.'" Nearly seventy years after her gift to the

priest, Esther Berning speaks with pride about her contribution; hers is the window closest to the church, between the niches of Counsel and Understanding. She told me how important it was for her to feel that she had given something tangible to the grotto.

The notoriety of the work under construction drew thousands of visitors to Dickeyville. Father Wernerus relied on the money he received from their contributions as well as the profits from the sale of souvenir pamphlets and pictures of the site.

Material and Technique

In addition to money, people contributed objects to be used in the construction of the grotto. Former parish priest Father Steffen, who grew up in nearby Platteville, recalled that his aunt used to tell stories about saving all the plates and glasses that would break throughout the year, because Father Wernerus wanted the pieces for his grotto. People also donated intact items, such as commemorative plates, teapots, and ceramic figurines. Such objects of remembrance would have been the link between the original owner and the event commemorated in the piece of clay, or would have connected the owner to the family's history and its origin in the old country. By contributing such items, donors were, perhaps, seeking a different kind of

remembrance, knowing that the object that they valued and that carried with it a bit of their family's private history would be forever on public display, and would be linked with the sacred through its inclusion in the grotto.

Most of the visible material was collected or purchased. In addition to rock available from nearby quarries, the work includes rose quartz from the Dakotas, stalactites and stalagmites from caves in Iowa, petrified wood, shell, coral, stone from New Mexico, and materials from the Holy Land and from Roman catacombs. Some of the exotic pieces were purchased from rock collectors. Father Wernerus himself gathered much of the material from caves in Wisconsin and Iowa. Glass and tile were purchased from a company in Kokomo, Indiana. When Wernerus acquired the glass, he melted some of it so that he could achieve a multicolored effect as the colors swirled together. Esther Berning recalled the technique: "When I was little, you bought syrup in a gallon bucket with a lid. The lid fit tight into the ledge of the bucket. He'd break up the glass and shut it tight and throw it in the furnace—regular old furnace used to heat the house. It would melt together and into a chunk. He'd take it out with a hammer and stick it in the cement."

Local guides tell visitors that "no accurate record of the amount of stone used in building was kept, but it is known that six or seven carloads of thirty tons each were

19

gathered from the Dakotas, from Iowa, and from nearby Wisconsin quarries. Over six thousand bags of cement were used." There are also a number of statues of white carrara marble. The statues for the Crucifixion Group were purchased from the Munich statuary company in Milwaukee, Wisconsin; no records of the purchase price or source of the other statues are available, nor are there records indicating how the arrangements were made to acquire the goods.

In building his grottos, Father Wernerus used cement, stone, and iron for the foundations and walls, and other materials— among them glass, coral, fossils, ceramics, and stones—to decorate the surfaces. There is no record of exactly how Wernerus worked. Other than the claim that blacksmith Leo Melssen drew the outline of the grotto on his garage floor with chalk, nothing indicates that Wernerus or his assistants worked from plans or drawings. The foundation of each structure was excavated deep in the ground and built of stone and cement. Visitors are told that the underground foundations include as much stone and cement as do the visible, above-ground structures. Support for architectural details was provided by iron bars and wire, bent to the shape required, and the walls were reinforced with iron. The widow of blacksmith Leo Melssen claimed that "Leo, he put iron bands one inch apart in that grotto to hold the rock

and the cement in place" ("Villagers Recall Work").

Most of the decorated surfaces are formed of concrete panels. During the winter months Father Wernerus worked in his house, preparing decorative panels that would be set in place once spring arrived. These panels were poured into wooden forms that varied in size depending on the area to be filled. The concrete was allowed to begin to set up. Then, the surface was decorated with the bits of glass, stone, or shell, or the glass rosettes made by Marie and Lina. When it was hard, the panel was removed from the form and set aside.

Many folk artists work in concrete, which, at the beginning of the century, must have seemed like a miraculous substance: it was relatively inexpensive and could be molded and shaped into elegant forms that seem to defy the rules of engineering. It certainly inspired folk artists to take risks, and to use it—perhaps to excess—as a medium for their expression. Many of these artists claim to have a secret that causes their concrete to be better than that of others. In Father Wernerus's case, he developed a particular mixture that seemed to work. Art Wiederhold, who hauled rocks for the project, noted that "he made it pretty rich and put lime in it" ("Villagers Recall Work"). A contemporary newspaper reported that the recipe was based on forty-five parts of fine sand, forty-five parts of cement, and ten parts of dehy-

drated lime. He also cured the cement very slowly, using a hose to keep it damp for several days. In this way, he hoped to achieve a hard and weather-resistant cement. To a remarkable degree, he was successful; there is relatively little visible deterioration of the surfaces of the Dickeyville grotto, though patches where damage has been repaired more recently have weathered noticeably less well.

The Grotto and the Public

Even before it was completed, Father Wernerus's work on the grotto was so well known that the site was drawing thousands of tourists. His obituary reports that "a register kept at the grotto showed that in nine months of 1930 over 30,000 visitors had registered and many came and went who were unaware of the presence of this register." At the height of its popularity, even more visitors came. Art Wiederhold boasted: "You know, as high as 10,000 people would come on a Sunday. The streets were just lined with cars and people. Every month there would be something new to see. You could go to Chicago and they'd say they had been to Dickeyville. At that time, Dickeyville was really noted" ("Villagers Recall Work").

Father Wernerus worried about the best way to provide for the needs of the visitors, as well as to pay for the work on the project. The sale of grotto pictures was not sufficient to generate income, especially as the grotto relied on repeat visitors who would be unlikely to buy the same souvenir twice. In June of 1929 he wrote Bishop McGavick for permission—which he eventually got—to build a small ice cream stand to help defray the grotto's expenses (letters of June 11, 1929, and June 29, 1929, from Wernerus to bishop; letter of July 1, 1929, from bishop to Wernerus).

The popularity of the grotto was confirmed in the pageantry surrounding its dedication. By 1930, Father Wernerus had completed the Grotto of Christ the King and Mary, His Mother. He had long since completed the Crucifixion Group and Shrine of the Holy Eucharist in the cemetery, and had recently finished the Shrine of the Sacred Heart; the Patriotism Shrine was nearly done. It was time to officially recognize the shrine's existence.

On September 14, 1930, Dickeyville hosted a dedication ceremony which drew thousands of visitors to see the shrine, hear an outdoor mass, and listen to a speech by the governor of Wisconsin, who arrived by plane. Newspapers reported that between ten and twenty thousand visitors attended the dedication, and that they had come from thirty-two states. A company of National Guard officers directed traffic and controlled crowds. The dedication opened at ten o'clock in the morning, with a high mass led by diocesan representative Msgr.

Kremer assisted by visiting priests. Later, a dinner was served to the dignitaries by women of the parish. At three o'clock, Wisconsin's Governor Kohler addressed the crowd; local papers carried the full text of his speech. The speech, carefully non-denominational and supposedly nonpolitical, equated Father Wernerus's work of providing a beautiful place for people to worship with Governor Kohler's own interest in beautifying the state's highway system and conserving its natural resources. Local bands played music throughout the day, and an evening program featured a candlelight procession, lighting of the grotto, and ceremonies that included the renewal of baptismal bows and recitation of a papal blessing. The program concluded with a fireworks display.

At the time of the dedication, newspapers, as well as parishioners who knew Father Wernerus, reported that the shrine was not finished. Father Wernerus left no description of the third group that he planned. He suggested to the bishop that he expected to finish that new group in 1932: "All what I can do is to finish the work and I hope that will be finished by the end of next year" (letter to bishop, January 19, 1931). Much later one of his parishioners, Barbara Melssen, recalled: "Father told me that fall [1930] that he wanted to build another one in the spring, with a statue in honor of St. Michael, on the other side of the priest house" ("Villagers Recall Work").

It is somewhat curious that Father Wernerus would hold a dedication for a project that had not yet been finished. While there are no records that explain his decision, it seems reasonable to assume that he may have wanted to include his cousin in the festivities. Marie was in her seventies at the time of the dedication, and would die less than two months later. If she was in failing health, Father Wernerus would surely have seen to it that the work was dedicated while she still had strength to enjoy the celebration.

One of Father Wernerus's major concerns was the matter of who would take custody of the shrine. After Marie's death, he worried that there were still debts to be paid, that his cousin was no longer there to help him, and that his own strength was declining. There are some hints that Wernerus felt that he had not received the support from other priests or from the diocese. He wrote to Bishop McGavick: "Those that tried to arouse my people and their people against us and made them believe that our work was nothing else but a money affair were I am almost ashamed to say it—my fellow priests" (letter to bishop, January 19, 1931). While there is no clear evidence for bad feelings between Father Wernerus and diocesan officials, there are hints that there was—at the least—some ambivalence about the grotto project on the part of the bishop. In a letter to Father Wernerus about the ice cream stand, the

bishop noted his interest in getting a financial accounting of the project; although Father Wernerus kept accounts of his expenses, there is nothing in the files to suggest that he shared the records with the diocese. Also, Father Wernerus fretted about the bishop's failure to respond quickly to his letters about the grotto. Finally, the bishop did not attend the dedication of the shrine, sending instead Msgr. Kremer as the diocesan representative.

If the bishop harbored any bad feelings about Father Wernerus or his project, it is likely that they were exacerbated by a proposal that the priest had first made to him around 1928: Father Wernerus wanted to remove custody of the shrine and church from diocesan control and bring in an order of monks to maintain the grotto and the parish. The bishop's silence on the matter provoked the priest to write a long and detailed letter to him on January 19, 1931, offering specific plans for the scheme. The letter was written at a low point in Father Wernerus's life: Marie had died in December, and later that month the priest suffered a severe case of pleurisy and bronchitis. In mid-January he was still very ill, and, for the first time ever, another priest took his place in mass. Father Wernerus was sick and depressed when he wrote to the bishop; he did not realize that within a month, he, too, would be dead. His letter thus has a special poignancy.

Wernerus was writing in response to a series of questions posed by the bishop (that letter is no longer in the files), and seeks both to clarify some misunderstandings on the part of the bishop and to propose a plan to bring a religious order to Dickeyville:

Regarding that "Guest-House" I believe that you misunderstood me. I don't want to build such a thing. I humbly ask your permission, Dear Bishop, that you give your consent to a Religious Order (like the good Capuchin Fathers or Franciscans) to build a convent or a Guest House at Dickeyville & permit those religious in due time to take care of the Congs. and of the shrine. It is in your power to bring peace and joy and happiness into the remaining years of my life. I cannot have any rest untill [sic] I know that the future of my work is assured. Three years ago I asked you for the permission that Religious men might be permitted in due time to take care of Dickeyville. You answered me thereupon that the shrine is a Diocesan affair, in other words, that I should not trouble myself about it. That, however, is little consolation to me because it leaves me in the dark of what will become of my work.

In furtherance of his argument, Father Wernerus offers a conversation he had with his dying cousin:

About 3 hours before my dear Cousin died, I said to her: "Mary, what shall I do now without your help? How shall I finish that big work?" She looked at me with tears in her eyes and said: "Don't worry! God is good! He helped us and He will help you to finish it."—Then her strenght [sic] was gone & for a while I thought the end had come. The nurse begged me to leave her alone for she thought I asked too much. After a while she rallied once more and said to me: "You must asked [sic] the Bishop that he permits pius [sic] Religious to come to Dickeyville and continue the work for which we brought so many sacrifices." Not knowing that death was so near, I said to her: "but suppose the Bishop will not what then—no, she said, the Bishop will not do that, just tell him all and the Bishop will help you"—She was perfectly exhausted. About ten minutes later she opened her eyes once more and said with a dying voice: "If you do not take care of this all our work will be in vain." That was the last I heard. I stood at the death bed of the best friend and dearest soul I had on earth; I laid my hand into the cold hand of that saintly woman and promised her that I would do everything to obtain that permission and to get pious religious men to continue our work. She understood what I said, but she could not speak anymore.—Dear Bishop, do you understand now when I say that there can be no peace, no joy, no rest, and no happiness for me untill [sic] I know for sure that you not only grant the permission but that you will help me, "that members of a religious order will come and take care of this place."

Wernerus knew that Dickeyville was drawing many visitors, and worried what this might do to the character of the shrine:

Judging from what I have seen and heard in the last two years I am thoroughly convinced that Dickeyville is destined to become the biggest pilgrimage in the country. . . . As soon as spring comes I hope to hire a new housekeeper and 1/2 doz. others to take care of the sale of articles. I have to keep up the selling of articles as long as I can, otherwise my people will come and steal the profit. As soon as the work is finished and they guess that the old debts are paid they will start out to build ice cream parlors and God knows what. How could I prevent that, unless Religious come to the place and take care of all? You know the old saying Dear Bishop "Where God errects [sic] a church, the devil builds a chapel." That saying might become true here in the truest sense of the word unless care is taken that the devil is out out [sic].

Father Wernerus had already begun to make specific plans for the convent:

The Man who owns the land just in front of the church (on the other side of the road) about 3 acres of land could sell it at any time for 5000.00. He promised me that he would not sell it to anyone provided I want to get it for a Religious order. In that case he would let me have it for 3500.00. Now suppose, Dear Bishop, that man would change its [sic] mind or would die!—There is the danger! That is one reason why I should like to get that thing cleared up.—. . . If you grant the permission to come and build a convent here, I will help them and they will get everything before I leave. Believe me, Dear Bishop, money could never compensate us for what we have done. We want to get something more precious than money for our work. My cousin's last wish and my wish is that our work will be carried on when I am no more. In asking you, Dear Bishop, to grant the permission & to kindly help me that the right religious come to this place I do not think that I ask too much. I should think it would be easy for you to find Religious that are willing to do it. The people here would receive them with open arms. They would all help them to put up the buildings. There are no debts on the Congs. and all the people are in the best spirit. Besides

I am willing to help make it a success. Of course I as well the people would prefer the good Capuchin Fathers. However, I like to hear you about this [sic].

In pressing his case to the bishop, Father Wernerus was perhaps a bit disingenuous: he not only preferred the "good Capuchin Fathers" but had already talked to them and gotten assurances of divine support for the plan. On the same day that the shrine was being dedicated, a Capuchin monk in Appleton, Wisconsin, was praying to Jesus to give him guidance on the plan for the order to take custody of the grotto. He wrote down the details of his vision for his confessor, Father Theophilus, who shared it in a September 18, 1930, letter to Father Wernerus:

Revelation Sunday 14, 1930 written from the 15th to the 16th, September 1930 and the questions which I put to our dear Saviour exactly as you had ordered me. On Sunday the 14th of September during Holy Mass I asked: "Should the Capuchins build a Retreat House at Dickeyville?" I requested our dear Saviour He should tell me Himself or let me be told by the Mother of God, Mary or by our holy Father Francis or by the little St. Theresa.

From the beginning of the Epistle till after the Gospel St. Theresa and the

Holy Father Francis gave me first the assurance that there is hope that the Capuchins will come there and St. Francis said, "Those that execute this work must be good enthusiastic Capuchins." Moreover the Holy Father Francis said it was not the Will of God that the Clericate of St. Anthony at Marathon should be changed because it had been said in a former revelation that Retreat House should be built elsewhere because Divine Providence has had [sic] already destined this place at Dickeyville and it is the Will of God that the Capuchins work for a Retreat House in Dickeyville, Wisconsin.

At Consecration I saw the Saviour with the crown of thorns on the cross on the altar, from the Agnus Dei till the last Gospel the Saviour appeared as the Divine Heart, approached and said, "Tell your Father Confessor (that is I) it is my Holy Will that the Capuchins build a Retreat House at Dickeyville, that in this place much can be done for the Honor of God and the Church and the salvation of immortal souls, many miracles and innumerable conversations will happen there." At the benediction appeared the Mother of God and said, "Tell your Father confessor this place is very near the Heart of my Son and pleases him very much since it is dedicated to Him as Christ the King and in my honor as the Mother of God."

The vision was clearly convincing to Father Theophilus, who concluded that:

That is the answer from Heaven, to our questions. Do we need more? From all the details with which the person has written down the revelation so minutely clearly appears its genuinness [sic].

Now then to work by zealous prayer. Show this letter also to your good aunt Mary. Her prayers has [sic] great value in the eyes of God. I shall at once communicate with Father Provincial and show him these revelations. To be sure hell will oppose, but it is God's Holy Will that we come there and it will happen. What a consolation for both of you to learn that you have accomplished a work with which Jesus and Mary are so well pleased and that such an infinite amount of good will be done there. Preserve this letter in your archives, because it has great historical significance.

It was not only hell that would oppose; it is likely that the copy of this letter Father Theophilus sent to Bishop McGavick caused him to oppose the project, too, and inspired him to send his long list of questions to Father Wernerus in December.

In making his request to the bishop to give control of the parish and shrine to the monks, Father Wernerus was probably following the model of a shrine popularly

called Holy Hill. Located in Hubertus, Wisconsin, the Shrine of Mary Help of Christians was established in 1885 by Irish settlers. The shrine quickly became a pilgrimage site and in 1906 the archbishop of Milwaukee gave control of the church and shrine to the Order of Discalced Carmelites of Bavaria, who both maintained and improved the shrine and built a monastery at the site. In 1931, they dedicated a spectacular new church at the site (Woods and Woods 1939:151; Office for the Pastoral Care of Migrants and Refugees 1992:38). Father Wernerus was aware of Holy Hill's importance as a place of pilgrimage, and likened the public response to his own grotto to that of the pilgrims to Holy Hill. The monks' work in improving the church at Holy Hill—done at the same time Father Wernerus was undertaking his own work—would surely have suggested to him the success of shrines maintained by religious orders.

Perhaps if he had lived longer, Father Wernerus could eventually have persuaded the bishop to allow the Capuchins to come to Dickeyville. The priest was still recovering from his bronchitis when he was asked to take the Last Sacraments to a sick parishioner. He came down with pneumonia and died on February 10, 1931. Dickeyville's Holy Ghost Parish and its grotto remained under diocesan control. There was no monastery or retreat house established at the site.

Symbolism

The visitor to the grottos at Dickeyville is left wondering why Father Wernerus created such things, and where he got the ideas. Unfortunately, definitive answers to these questions cannot be given.

In the foreword to an illustrated pamphlet distributed to visitors, Father Wernerus wrote: "Many reasons urged me to put up 'Religion in stone and Patriotism in stone.' The main reason why it was done I could not reveal. The last day will tell you more about that" (Wernerus ca. 1930). In the January 19, 1931, letter to his bishop, Wernerus gave further insight into his motivations: "The work was started as an act of Reparation for the blasphemies against Christ the King and Mary His Mother. The sinners for whose conversion I had no hope anymore have come back. Our Dear Lord has accepted our sacrifice." Wernerus was silent on the identities of the sinners.

He was similarly silent on the specific source of ideas that he used in his work, though it is possible to reconstruct some of them. The exterior of the grotto structure was of particular importance. Wernerus wrote: "We needed the help of the Holy Ghost in the erection of the Grotto. To draw down a special blessing from the Spirit of Light and Love we resolved to represent the Seven Gifts and the 12 Fruits of the Holy Ghost on the outside of the walls" (Wernerus ca. 1930). The writings

of St. Thomas Aquinas named the seven gifts and the twelve fruits that are mentioned, perhaps metaphorically, in several biblical passages. Official interest in the Holy Spirit—and in Aquinas's interpretations of it—was renewed in 1897 in an encyclical issued by Pope Leo XIII (*Divinum illud munus,* "On the Holy Ghost"), which remarks particularly on the power of the Holy Spirit to call sinners back from their wicked ways. Mathias Wernerus would have been entering his religious studies in Liege when the pope's directive was new. It seems probable that he would have been taught the importance of Aquinas's literal interpretation of the gifts and fruits— particularly as Pope Leo's political policies had made him especially popular with Belgian Catholics.

An additional biblical referent to the Holy Spirit and the Tree of Life might also be relevant. The book of the Apocalypse (last book in the Catholic Bible, called Revelation by Protestants), describes the new Jerusalem that would descend from heaven to a sin-purged world (Apoc. 21:10–11): "And he took me up in spirit to a great and high mountain: and he shewed me the holy city of Jerusalem coming down out of heaven from God, Having the Glory of God. And the light thereof was like to a precious stone, as to the jasper stone, even as crystal." It continues: "And the wall of the city had twelve foundations: and in them the twelve names of the apostles of the Lamb"

(Apoc. 21:14). The Tree of Life appears here, too: "In the midst of the street thereof was the tree of life, bearing twelve fruits, yielding its fruits every month: and the leaves of the tree were for the healing of the nations" (Apoc. 22:2). The city's materials are described elsewhere in the text: "And the building of the wall thereof was of jasper stone: but the city itself was pure gold, like to clear glass. And the foundations of the wall of the city were adorned with all manner of precious stones. The first was jasper: the second, sapphire: the third, a chalcedony: the fourth, an emerald: The fifth, sardonyx: the sixth, sardious: the seventh, chrysolite: the eighth, beryl: the ninth, a topaz: the tenth, a chrysoprasus: the eleventh, a jacinth: the twelfth, an amethyst" (Apoc. 21:18–20).

Wernerus's public assertion that the true meaning of his work would be revealed "on the last day" suggests a reading of the building through this apocalyptic text. Present in his plan are a foundation wall with the names of the twelve apostles and an image of a tree bearing twelve fruits at the midpoint of the grotto's wall. His grotto, of precious and semiprecious stones and shiny glass, may well have been his interpretation of the new Jerusalem that awaited redeemed sinners on that "last day."

Much of the symbolism of the religious grotto draws clearly from Catholic iconography that can be read immediately by a

visitor familiar with this symbol system. But there is another level of symbolism which requires faith on the part of the visitor. The symbolism of substance was important to Father Wernerus. He claimed to have gotten material for the grotto from many places and to have reserved the most precious material for the most sacred parts of the shrine. Visitors are told that stone from the Holy Lands was used to work out the symbols of the Passion, and that material from the Roman Catacombs of Domitilla and St. Sebastian are used in the niches of the ambulatory (*Grotto and Shrines*). The casual visitor has no way to distinguish these sacred rocks from the similar-looking but ordinary rocks that abound in the grotto. A crucifix on the altar of the interior of the grotto is described to visitors as an object made by or given to an Indian convert of Father Marquette, and its monetary and historical value is stressed. Yet its validity cannot be discerned visually, and even literature available at the grotto notes that this piece is only "alleged" to have been associated with the explorer (*Grotto and Shrines*). The substances and objects found in the grotto reveal their meaning only through the narratives that attest to their context or provenience.

The iconography of the Patriotism Shrine is of interest, for it provides both a secular and a sacred reading. In the construction of the religious grottos, Father Wernerus was following the canons of Catholic art. In designing a shrine to patriotism, he also drew from this tradition. In particular, he echoed the composition he presented in the niched walkway of the religious grotto.

As a secular construction, the Patriotism Shrine is dominated by a nautical motif, seen in the anchors that decorate the curved wall. The fact that Columbus "sailed the ocean blue" is made visible by the use of blue glass to provide the background and the lavish use of conch and abalone shells in the arch that frames him. But these same elements offer a religious reading, too. The anchor is, in Catholic iconography, a symbol of hope, which might be used here to show the hope and promise offered by the new land. And the symbolic importance of colors is stressed in the religious grotto. The Liberty Bell, paired with an invented Unity Bell, which might be considered purely secular, calls to mind the importance of bells in churches, and especially, the Peace Bell and its mate which Father Wernerus had cast for the church to commemorate the end of World War I.

The form of the Patriotism Shrine is a refraction of the religious images seen in the niched walkway of the Christ the King shrine. There, a large central image of Jesus is flanked by smaller apostles; in the Patriotism Shrine, Columbus takes center position, with Washington and Lincoln standing in for the apostles. In the religious group, Christ is depicted as traveler between

heaven and earth and establisher of a new order that is furthered by his apostles; in the patriotic group, Columbus's voyage to America is given visual emphasis, and the new order he established is implicit in the choice of his apostles, Washington and Lincoln. In the religion group, lambs at the base of Christ symbolize his gift of peace to his earthly kingdom; the base of the Patriotism Shrine is said to include axes, arrowheads, and other artifacts donated by Indians and incorporated into the shrine in an unironic statement of Columbus's contribution to an American world order. Finally, in the religion group, Christ gazes at the upturned dove that symbolizes the Holy Spirit; in the patriotism group, Columbus gazes on a three-tiered fountain surmounted by an eagle, symbolizing the United States.

Why should Columbus be the visual focus of this group, rather than Washington or Lincoln? Visitors are reminded by the image of the anchor juxtaposed with a cross that he brought Christianity to the Americas, an image that fuses the religious and patriotic themes of the grotto. But perhaps more significantly, he was a European who crossed the ocean to lands his compatriots had not visited, a man who, in the romantic constructions of the 1920s, might have been seen unambiguously as someone opening new worlds of possibility to the people of Europe. The priest who built the grotto had been born in Europe, and many of his pa-

rishioners were also from immigrant families. It is perhaps not surprising that a figure who made a similar crossing would be a more central personage than two English-speaking men who were important only in the political history of the United States, rather than in the history shared with the Old World.

By looking at the chronology of Father Wernerus's works we might begin to see why he chose to balance the themes of religion and patriotism in his shrine. His first work as a folk artist was devoted to the elaboration of the Crucifixion Group made to commemorate the death of three local boys in the world war. While the construction of soldiers' memorials is hardly unique to Dickeyville, we might notice that the dead heroes have German names: Michael Jenamann, Michael Loeffelholtz, and Albert Riemenapp. The fact of their deaths is reported, yet the inscribed plaque dedicated to them leaves ambiguous their military loyalties: one died of disease in camp; one died of disease in France; one died in battle in France. Although we know that they fought for the American cause, the plaque doesn't tell us this fact. We can imagine the same names and the same inscription on a similar plaque in a small town in Germany, a recognition of the sacrifice of its young men.

In creating the Crucifixion Group, Father Wernerus reorganized the cemetery, creating an axis to divide the old section of

the graveyard from the new. Many early gravemarkers are inscribed in German; in the new section of the cemetery, most headstones still bear German surnames, but most inscriptions are in English. In many German-American communities in the Upper Midwest, World War I brought about an abrupt and forcible move away from the speaking of German and the professing of a German identity. At Dickeyville this larger social transformation is made visible in the early building project. It tangibly divides the old linguistic and social order from the new, and it commemorates the sacrifice of its native sons on behalf of that new community. The Dickeyville grotto marks the emergence of a new identity for the German-American citizens of Dickeyville. It is an adamant statement of their political loyalties and of their devotion, not only to their faith, but to their adopted country.

Sources of Inspiration

While it is possible to trace the iconography that Father Wernerus used, we are still left with the question of why he chose to render his work in concrete, rock, and glass. Although parishioners believe that he was copying a German tradition of grotto building, the closest parallels to his work are seen in the tradition of religious grotto building that was present in the American Midwest early in the twentieth century.

The tradition seems to have been inspired by the work of Paul Dobberstein. Born in Rosenfeld, Germany, in 1872, Dobberstein emigrated to the United States and decided to become a priest. Like Wernerus, he studied at St. Francis Seminary in Milwaukee (where he may have helped to build a grotto), and in 1898 went to West Bend, Iowa, as priest of the German-speaking parish. In 1912, he began to build the Grotto of the Redemption (plate 32). Taking the form of a mass of mountains—complete with snow peaks and hanging glaciers—each of its component grottos is a faux cave displaying scenes from the narrative of the fall of humans and their redemption in the life and sacrifice of Jesus. The massive work is built of concrete with dense covering of rocks and minerals, especially crystals, precious and semiprecious stones, and geodes. Begun in 1912, work on the Grotto of the Redemption continued after Dobberstein's death in 1957 under the direction of Rev. Louis Greving. Dobberstein also designed and built smaller fountains and grotto structures in towns, cemeteries, and convents throughout Iowa, South Dakota, and Wisconsin, fabricating the panels that would be used in their construction and shipping them via rail to their building site. A grotto he designed for Mt. St. Francis Convent in Dubuque (just across the river from Dickeyville) was completed in 1929, while Father Wernerus was finishing his own grotto.

31

Several studies have explored the relationship between these artists, and some suggest that Wernerus visited Dobberstein and learned from him the rudiments of grotto building (Stone 1990; Beardsley 1995). Unfortunately, there is no documentary evidence that Wernerus did so.* Whether or not he assisted Dobberstein, it is likely that Father Wernerus saw the grottos in West Bend in person, as his earliest work is especially reminiscent of Dobberstein's work there. West Bend is about 260 miles west of Dickeyville, and by 1939 had hosted a million visitors (Woods and Woods 1939:49). If he traveled to West Bend, it is hard to imagine that Wernerus would not have spoken to its builder, who was also German born, a product of St. Francis Seminary, and was his own age. If nothing else, Dobberstein could surely have given advice on how to arrange for the purchase of exotic stone, as both grottos make lavish use of rose quartz from the Dakotas.

There are obvious stylistic similarities between Dobberstein's work and Wernerus's first building efforts. One of the earliest grottos at West Bend is Mary's Grotto, the interior of which bears striking similarities to aspects of the interior of the Dickeyville grotto. The central figure in both is a marble statue of Mary holding a toddler-sized Jesus who faces outward with arms raised. The statues are not identical, but they clearly depict the same aspect of Virgin and Child. In both, Mary is placed in an arched niche with a starry blue background. Inlays in the interior wall at West Bend include a chalice, wheat and grapes (symbols also seen in the Eucharist Grotto at Dickeyville), and a priestly stole and keys of heaven (as in the interior of Dickeyville's grotto). The Eucharist Grotto at Dickeyville shares with West Bend's grottos a lavish use of gold tile to work out legends. The Grotto of Paradise Lost at West Bend has an image of the Tree of Knowledge, which, though different in design, may have influenced Father Wernerus's depiction of the Holy Ghost Tree (plate 33).

The artistic influence may have gone both ways. The Holy Family Grotto designed by Dobberstein and built at Villa St. Joseph, near La Crosse, by Frank Donsky, includes features present in Wernerus's work, grafted onto a structure that looks like Dobberstein's faux mountains (plate 34). Most interesting is a set of dedicatory dates (1925 and 1930) and paired flags (plate 35). In contrast to most of

<hr />

* The claim that Wernerus consulted with Dobberstein is attributed to Father Louis Greving, Dobberstein's former assistant and successor (Beardsley 1995: 114; Stone and Zanzi 1993: 45). I asked Father Greving if there was any documentary proof of Wernerus's visit, but he told me there was no such record (reply to letter, S. Niles to L. Greving, June 19, 1996). Greving did not join Dobberstein until 1946 (Hutchinson 1989: 26), well after Wernerus's death and could not himself have known firsthand about any meeting that may have taken place between the two priests.

Dobberstein's work, this grotto has added touches of brightly colored glass to depict a whimsical palm tree and legend (GROTTO). Such touches seem certain to have been introduced by a builder who had visited Dickeyville, as the style and media are not ones used elsewhere by Dobberstein.

Whatever the debt owed to Dobberstein by Wernerus, the latter quickly developed his own distinctive style. Dobberstein uses only minerals and shiny tiles and, at West Bend, depicts exclusively religious themes. By contrast, Wernerus makes comparatively little use of exotic stone and gems, and favors colored glass. He further includes ceramics, figurines, and secular objects donated by visitors to his project. Coupled with the fact that he celebrated both the Catholic faith and the American identity in his shrines, Wernerus's works seem more accessible to a broader base of visitors.

In his work, Father Wernerus aspired to a creation that would have universal appeal. He wrote: "God's wonderful material, collected from all parts of the world, has been piled up in such a way that it appeals to rich and poor, to educated and uneducated, to men, women and children alike" (Wernerus ca. 1930).

For the dedication ceremony, he placed an ad in the Dubuque newspapers. It was directed "To all Friends of the Grotto— Catholic and Protestant" who were invited to "Jump into your car and drive to Dickeyville on Sunday, Sept. 14—25,000 others will be there!" ("Invitation to the Dedication").

Perhaps because of its broader appeal, Wernerus's work inspired a lively tradition of grotto building throughout the Midwest, one which crosses religious lines. Paul and Matilda Wegner, German immigrants, visited Dickeyville several times while the grotto was under construction, and were inspired to build similar works at their home near Cataract, Wisconsin. Between 1929 and 1936, they used Wernerus's technique of studding concrete with glass and ceramic objects, and transformed his Catholic iconography into one that fitted their own Lutheran background and ecumenical bent. An eight-foot-by-twelve-foot Glass Church has exterior mosaics depicting churches of many faiths, with the three great religions of the German tradition (Lutheran, Catholic, Jewish) on the front under the legend ONE GOD ONE BROTHERHOOD (plate 36). Steps dedicated to the twelve apostles connect the church to an outdoor pulpit and Jacob's Well (plate 37). A religious meaning is also attributed to a twelve-foot replica of the German steamship *Bremen* ("Objects Constructed of Tiny Bits of Glass . . ."), which has the legend TAKE CHRIST IN YOUR LIFEBOAT inscribed on its concrete deck. The German-American identity of the builders is confirmed in the Travelers'

Bench, with its bilingual inscription (FOR THE TIRED TRAVELER/FÜR DEN MÜDEN WANDERER). Much of the construction commemorates patriotic ideals (an American flag, American Legion monument, and Gold Star mothers' monument) or celebrates hearth (a glass fireplace mantle), home (the entry gate to the homestead, plate 38), and family (a four-foot-tall replica of Paul and Matilda's fiftieth wedding anniversary cake, plate 39).

Wernerus's work also inspired Methodist John Kobes to build "The World's Smallest Dedicated Church Grotto" in his backyard in Iowa City, Iowa (Ohrn 1984: 140). Weathered concrete constructions are decorated with tile and crockery, and the base includes mosaics formed of pearl buttons and buckles (plate 40).

The art at Dickeyville was the direct inspiration for several purely secular grottos, as well, including a family and community history begun in the 1950s by avowed atheist and German immigrant Paul Friedlein, at Guttenberg, Iowa (Ohrn 1984), and the now-vanished Mollie Jenson's Art Exhibit, built in the 1940s at River Falls, Wisconsin (Stone and Zanzi 1993:86–92). Numerous other grottos, rock gardens, and concrete parks in the Upper Midwest—most notably in Wisconsin, Iowa, and Illinois—may well owe their inspiration at least in part to Father Wernerus's works.

Epilogue

More than six decades have passed since Father Wernerus's death, but little has changed in Dickeyville. The village retains its identity as a German and Catholic community, and Wernerus's fear that the grotto would be subject to tasteless commercialization was never realized. The tens of thousands of people who visit the grotto each year must go to Dubuque or Platteville to buy ice cream. Other than the addition of sandstone and concrete stations of the cross by parish priest Lambert Marx in 1964, the grotto and its grounds are unchanged. Each year on the anniversary of its dedication, community attention is focused on the grotto at a mass followed by a church picnic.

Mathias Wernerus wrote that "I have succeeded a thousand times better than I ever thought I would. They come from far and near, non-Catholics as well as Catholics, and find that here is something that appeals to them in a religious way. Here is something that touches their hearts and raises their thoughts to God" ("One Man's Work"). His words are still true.

References

Beardsley, John. 1995. *Gardens of Revelation: Environments by Visionary Artists.* New York: Abbeville Press.

Commemorating a Century of Growth in Holy Ghost Parish Dickeyville, Wisconsin, 1873–1973. 1973. Dickeyville: Holy Ghost Parish.

Greving, Louis H. 1993. *A Pictorial Story of the Grotto of the Redemption.* West Bend, Iowa: The author.

Grotto and Shrines. N. d. Dickeyville, Wis.: n. p.

"The Grotto at Dickeyville." 1933. *The Witness* (Dubuque, Iowa), August 24.

"Grotto Rites at Dickeyville." 1930. *Herald* (Cuba City, Wis.), September 19.

"Grounds Keeper for 20 Years." 1980. *The Platteville* (Wis.) *Journal.* September 11.

The Holy Bible. The Catholic Bible. Douay-Rheims Version. 1944. New York: Benziger Brothers, Inc.

Hutchinson, Duane. 1989. *Grotto Father: Artist-Priest of the West Bend Grotto.* Lincoln, Neb.: Foundation Books.

"Invitation to the Dedication." 1930. *Telegraph-Herald and Times-Journal* (Dubuque, Iowa), September 12.

"Kohler and Grotto Draw Thousands to Dickeyville Today." 1930. *Telegraph-Herald and Times-Journal* (Dubuque, Iowa), September 14.

Leo XIII, Pope. 1938. "Encyclical on the Holy Ghost (*Divinum Illud Munus*)." *The Catholic Mind* 36 (849): 161–81.

Mulhern, P. F. 1967. "Gifts of the Holy Spirit." *New Catholic Encyclopedia* 7:99–101.

Niles, Susan A. 1993. "The Shrines at Dickeyville." *Lafayette Magazine* 63, no. 2:14–19.

Obituary. Mathias Wernerus. 1931. *Wisconsin State Journal* (Madison), February 15.

Office for the Pastoral Care of Migrants and Refugees, United States Catholic Conference. 1992. *Catholic Shrines and Places of Pilgrimage in the United States.* Washington, D.C.: United States Catholic Conference.

Ohrn, Steven. 1984. "Faith into Stone: Grottoes and Monuments." In *Passing Time and Traditions: Contemporary Iowa Folk Artists,* ed. Steven Ohrn, 129–41. Ames: Iowa State University Press for the Iowa Arts Council.

"One Man's Work." 1980. *The Platteville* (Wis.) *Journal,* September 11.

"Platteville Guards Served Without Pay at Dickeyville." 1930. *Telegraph-Herald and Times-Journal* (Dubuque, Iowa), September 16.

Stone, Lisa. 1990. "Concrete Visions: The Midwestern Grotto Environment." *Image File* 6, no. 2:3–6.

Stone, Lisa, and Jim Zanzi. 1993. *Sacred Spaces and Other Places. A Guide to Grottos and Sculptural Environments in the Upper Midwest.* Chicago: The School of the Art Institute of Chicago Press.

"Thousands Hear Kohler Sunday at Dickeyville." 1930. *Telegraph-Herald and Times-Journal* (Dubuque, Iowa), September 15.

"Villagers Recall Work." 1980. *The Platteville* (Wis.) *Journal,* September 11.

Wernerus, Mathias. Ca. 1930. *The Grottos at Dickeyville.* Dickeyville: n. p.

Woods, Ralph L., and Henry F. Woods. 1939. *Pilgrim Places in North America: A Guide to Catholic Shrines.* New York and Toronto: Longmans, Green and Co.

Unpublished material

In files of Holy Ghost Congregation, Dickeyville, Wisconsin:

Speech prepared for tour guides, Dickeyville Grotto. N. d.

Information about the grotto. Handout dated October 15, 1986.

Rumpelhardt, Charles. Ca. 1918. Summary of the accounting of expenses in the construction of the church. Prepared for Holy Ghost Congregation.

Wernerus, Mathias. 1920a. Short Summary of the History of the Holy Ghost Congregation at Dickeyville, Town of Paris, Grant Co., Wis. 1872–1920. In pamphlet prepared for the Holy Ghost Congregation.

———. 1920b. Accounting of parish expenses, 1919. In pamphlet prepared for the Holy Ghost Congregation.

In diocesan archives, La Crosse, Wisconsin:

Bishop of La Crosse. 1929. Letter to Mathias Wernerus, July 1.

Father Theophilus. 1930. Letter to Mathias Wernerus, September 18.

Wernerus, Mathias. Ca. 1904. Mein Lebenslauf (curriculum vitae).

———. 1904. Letter to the director of St. Francis Seminary, May 30.

———. 1904. Letter to the director of St. Francis Seminary, July 1.

———. 1929. Letter to Bishop of La Crosse, June 11.

———. 1929. Letter to Bishop of La Crosse, June 29.

———. 1931. Letter to Bishop of La Crosse, January 19.

In St. Rose Convent archives, La Crosse, Wisconsin:

Sister M. Valentina. 1960. St. Rose Convent Grotto: History and Description.

Notes Regarding Materials in St. Rose Convent Grotto and Their Respective Sources.

A History of the Villa, St. Joseph's Ridge.

In Monroe County Local History Room, Sparta, Wisconsin:

"Objects Constructed of Tiny Bits of Glass Form Unique Display at Home of Paul Wegner Near Sparta." 1931(?). *La Crosse Tribune* (La Crosse, Wis.).

Shmig, Norma Culpitt. N. d. "Staying with Grandpa & Grandma (Story by Norma Culpitt Shmig of her Memories of Staying at the Glass Church Farm with Charlie and Eliza Wegner)." Handwritten manuscript.

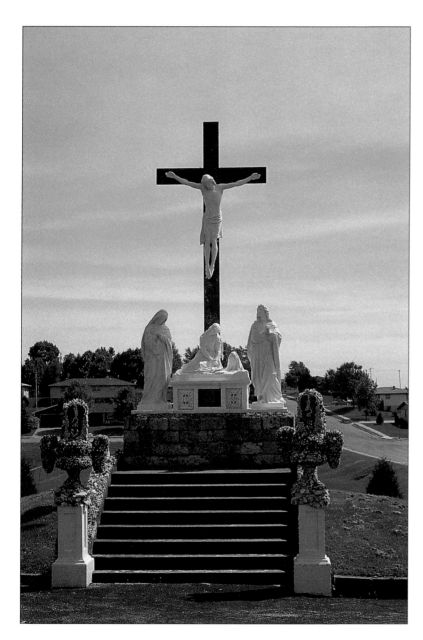

PLATE 1
Overview, Crucifixion
Group. A plaque dedi-
cates the construction to
three young men of the
parish who died in World
War I.

P L A T E 2
Detail, concrete, glass,
and stone vase, base of
the Crucifixion Group.
This is likely Wernerus's
first concrete construction.

3 8

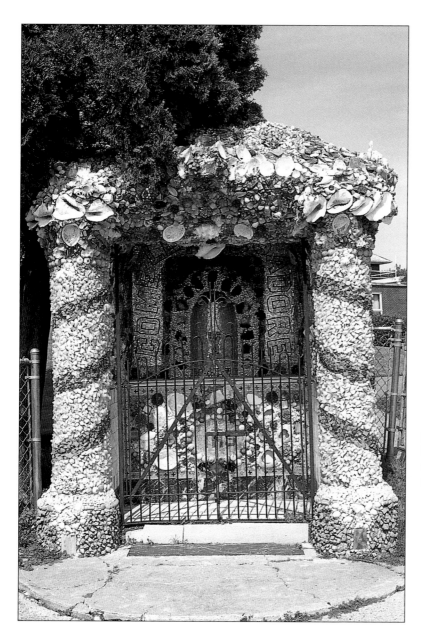

PLATE 3
Front of the Grotto of
the Holy Eucharist in the
cemetery.

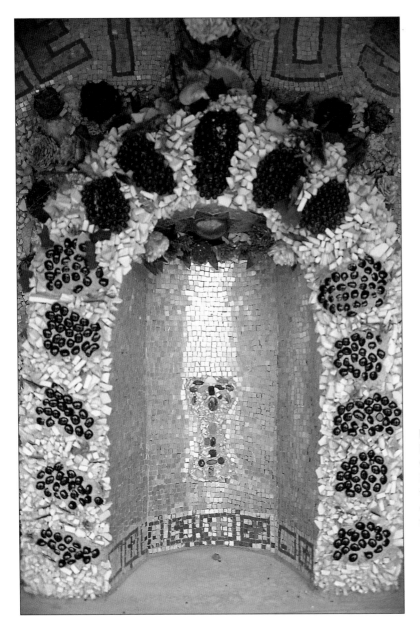

PLATE 4
Detail of interior altar,
Grotto of the Holy
Eucharist. The arch above
the niche depicts bunches
of grapes; an inlay shows
the chalice cup.

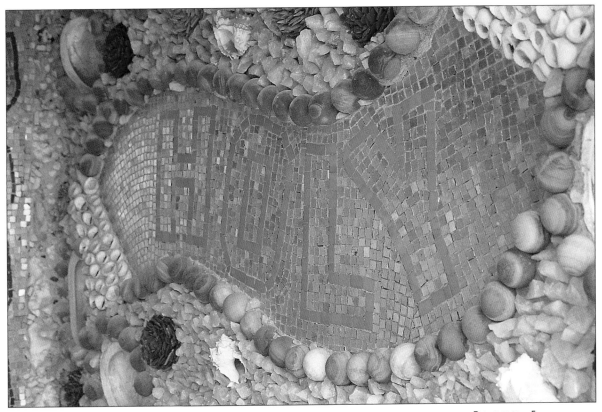

PLATE 5
Detail, interior of the
Grotto of the Holy
Eucharist. HOLY is spelled
out in tiles outlined by
gearshift knobs.

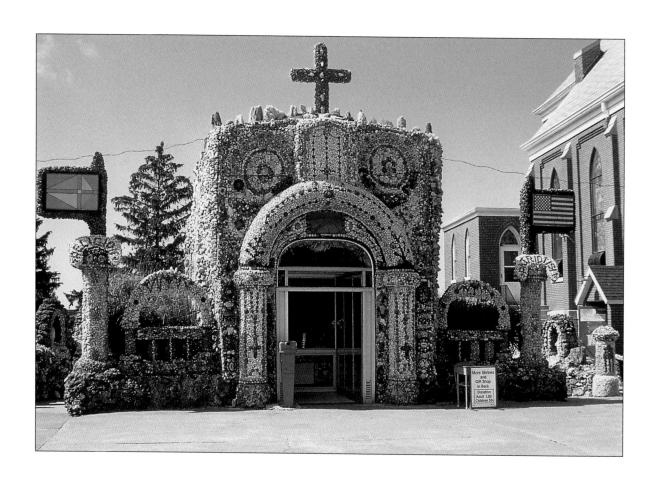

P L A T E 6
Front façade, Grotto of
Christ the King and Mary,
His Mother.

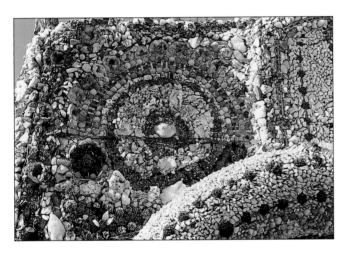

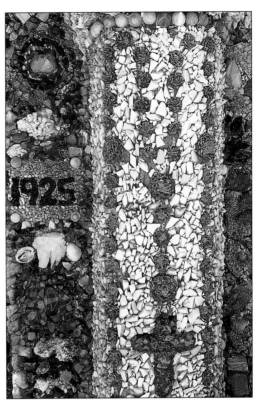

P L A T E 7
Detail, grotto front wall.
The join of the glass-
studded concrete panels
that form the façade is
clearly visible.

P L A T E 8
Detail, dedicatory date
and rosary from left front
façade of the grotto.

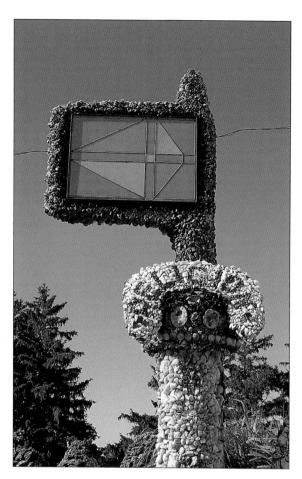

PLATE 9
Detail, Vatican flag,
grotto front wall, left.

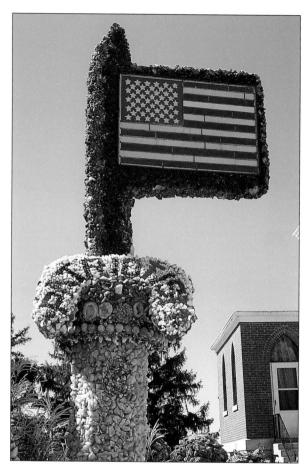

PLATE 10
Detail, American flag,
grotto front wall, right.

44

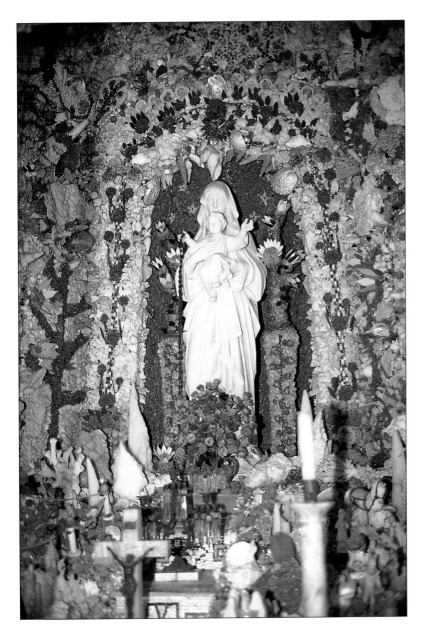

PLATE 11
Grotto interior, statue of
Virgin and Child framed
in an arch decorated with
shells, stalactites, and
glass rosettes.

PLATE 12
Detail, grotto interior, of
the theological virtue
FAITH.

46

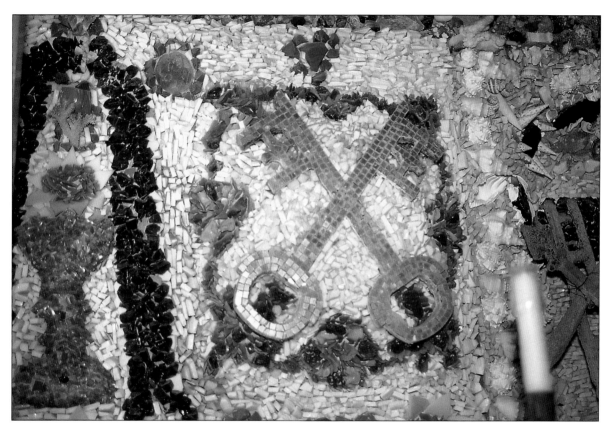

PLATE 13
Detail, grotto interior:
stole and chalice, left, and
keys of heaven, right.

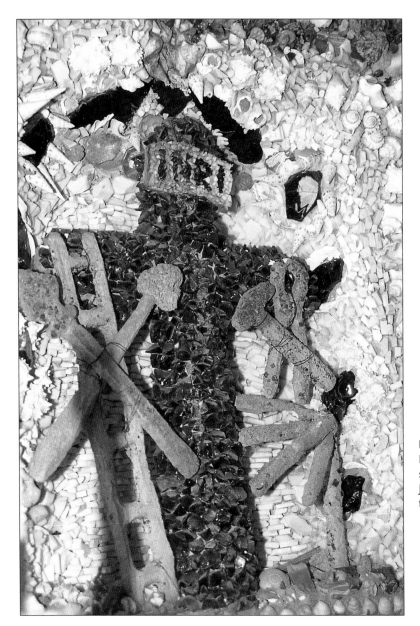

48

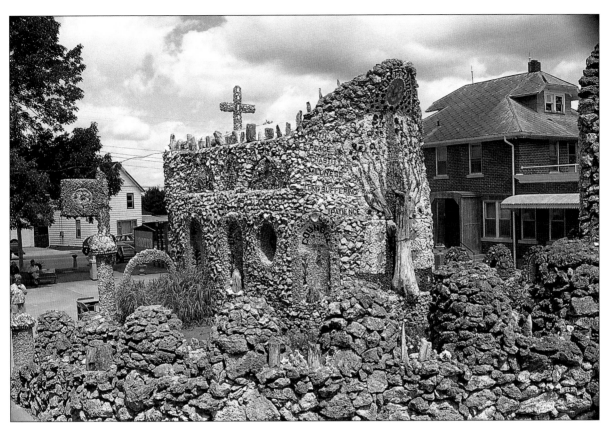

PLATE 15
Overview of outside wall
of the grotto showing
some of the niches
dedicated to the gifts of
the Holy Spirit.

49

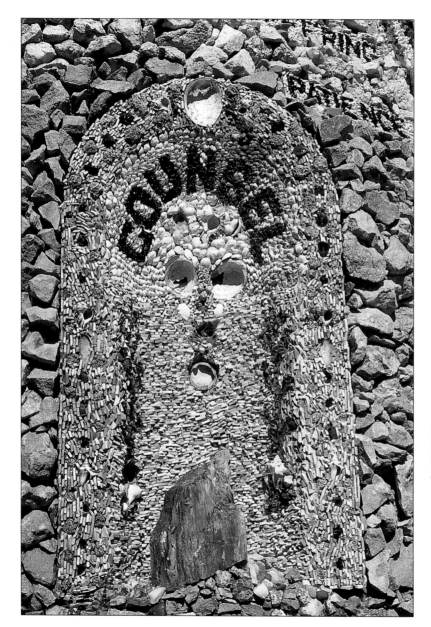

PLATE 16
Detail, niche of
COUNSEL, grotto
exterior.

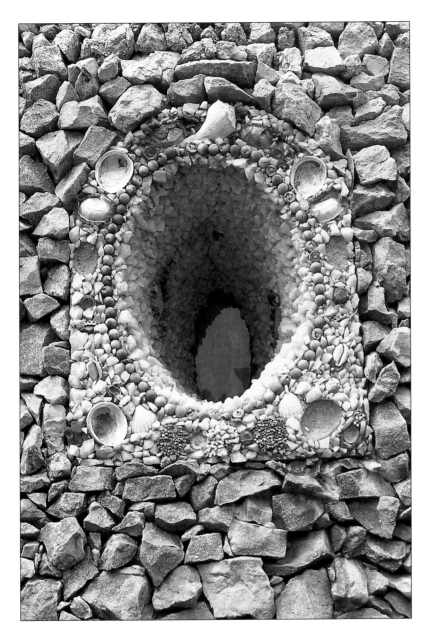

P L A T E 1 7
Detail, window seen from
grotto exterior. The inset
window was purchased
with money donated by
Esther Timmerman
Berning.

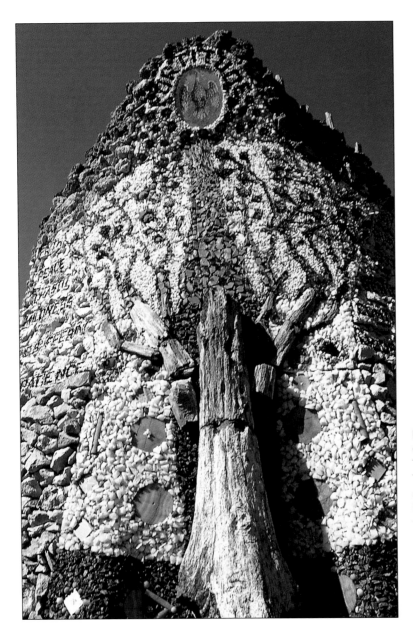

PLATE 18
Overview, Holy Ghost
Tree, grotto exterior.
The base is formed from
a petrified tree trunk;
branches and fruits are
worked in glass.

52

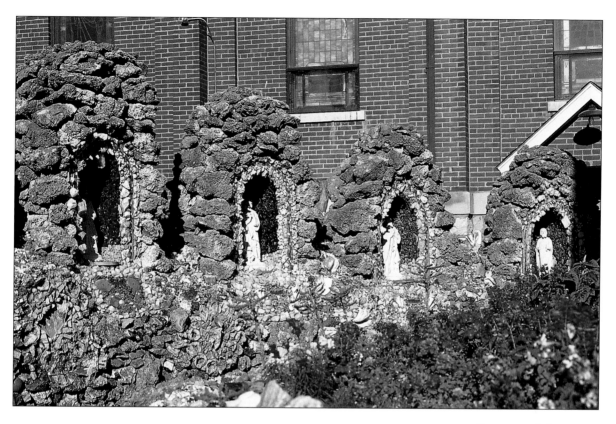

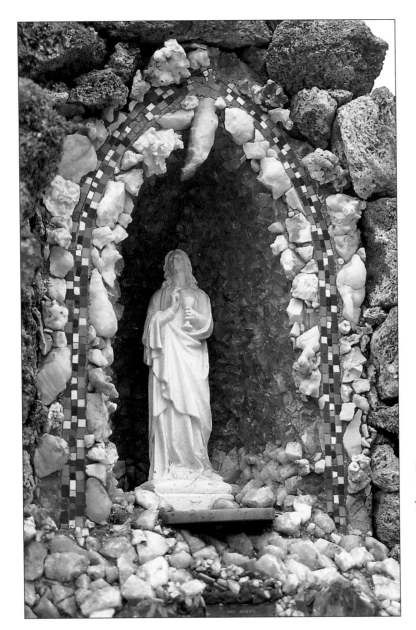

PLATE 20
Niche dedicated to St.
John, Grotto of Christ
the King.

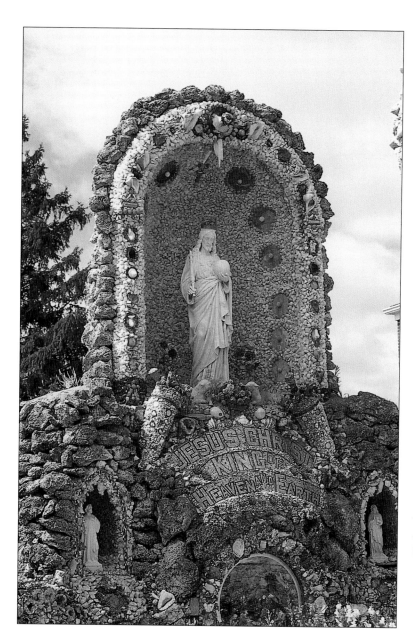

P L A T E 2 1
Overview, large niche
housing Christ the King.
Tiles spell out JESUS
CHRIST KING OF
HEAVEN AND EARTH.

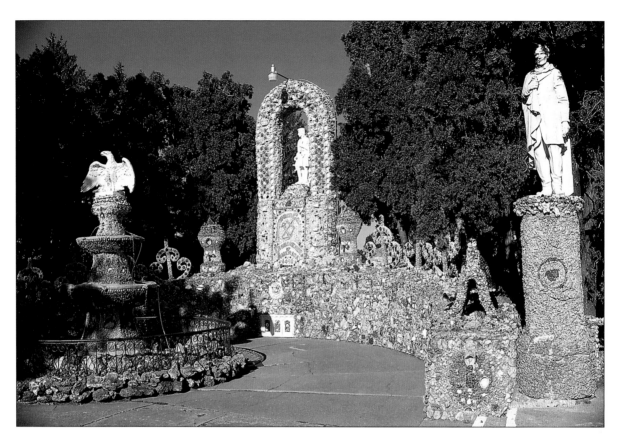

P L A T E 2 2
Overview, Patriotism
Shrine, with Abraham
Lincoln in the right
foreground.

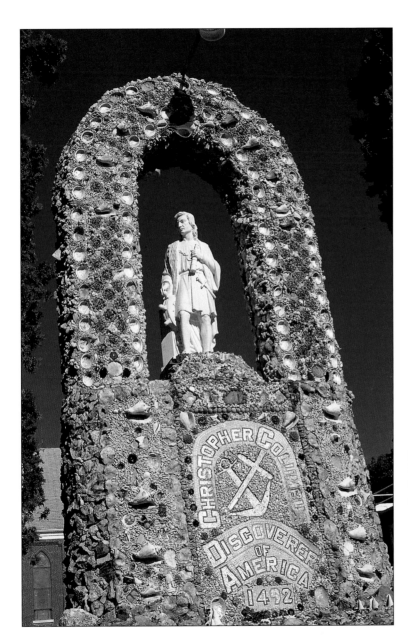

57

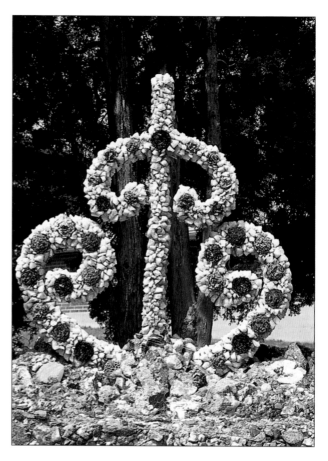

PLATE 24
Detail, base of
Christopher Columbus
statue, with nautical
theme suggested by light
blue glass, shells, and a
ceramic sailor boy.

PLATE 25
Detail, anchor from the
curved wall of the
Patriotism Shrine.

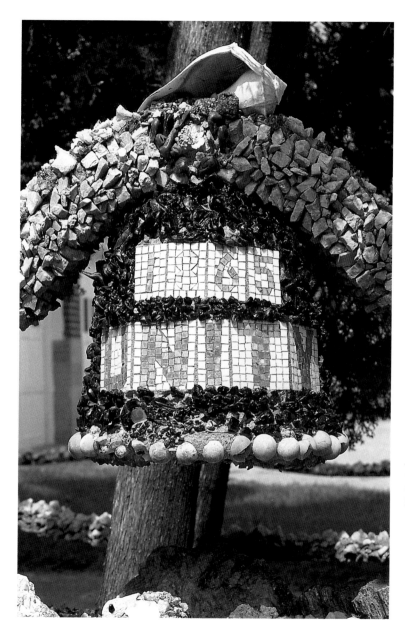

PLATE 26
Detail, Unity Bell,
Patriotism Shrine.

59

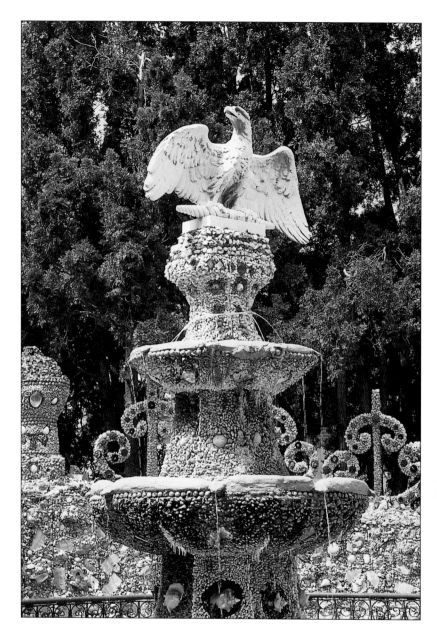

PLATE 27
An eagle, symbolizing the
American government,
tops a fountain in the
Patriotism Shrine.

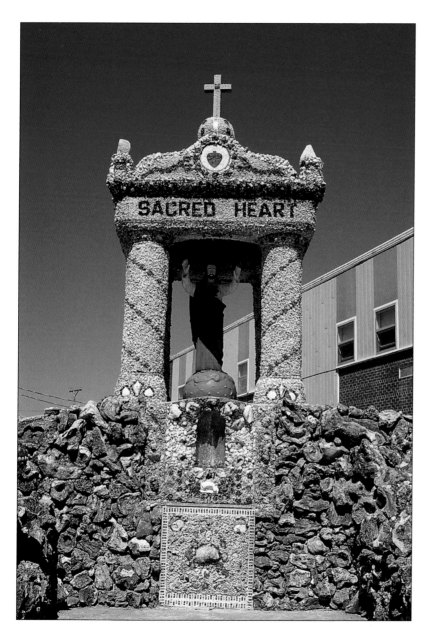

SACRED HEART

PLATE 28
Overview, Sacred Heart
shrine.

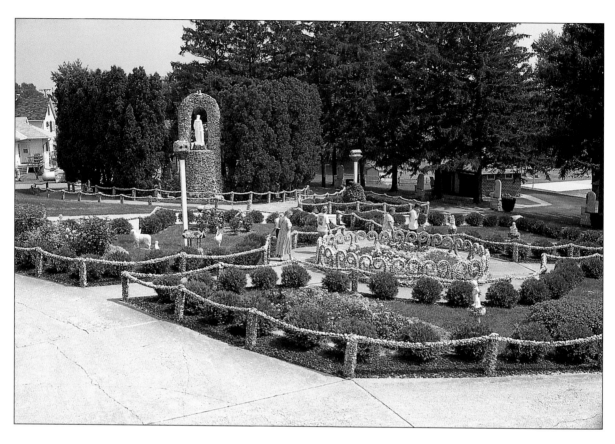

PLATE 29
Overview of the park and
gardens behind the main
grottos.

62

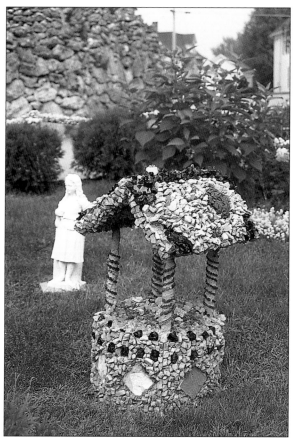

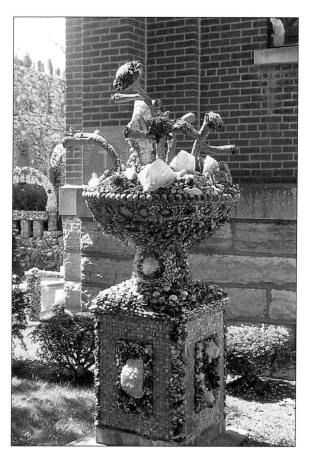

PLATE 30
Detail, Rebecca's Well in
the grotto park.

PLATE 31
Flower pot in front of
Holy Ghost Church. The
flower arrangement is
made of branches of
petrified wood, crystals,
and glass.

63

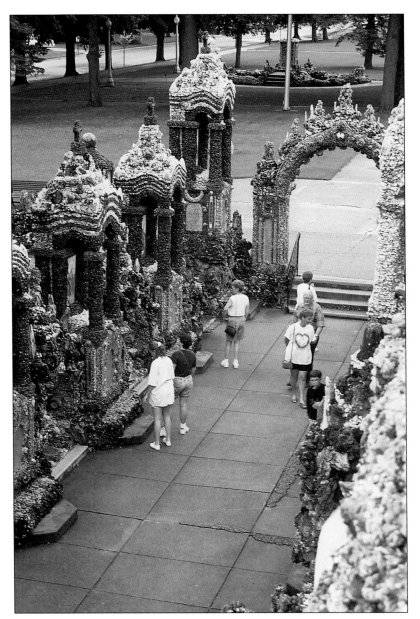

P L A T E 3 2
Overview, Stations of the
Cross at the Grotto of
the Redemption, West
Bend, Iowa.

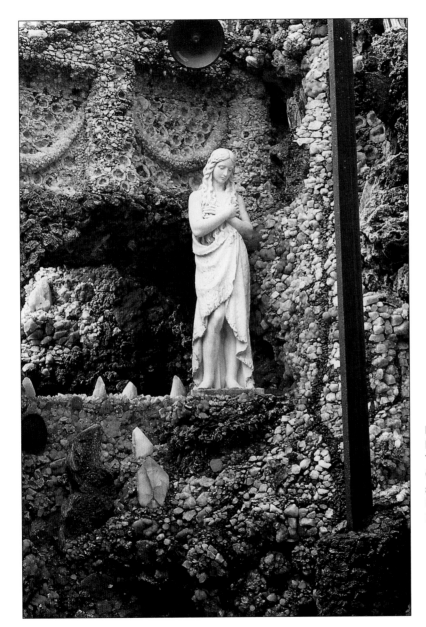

PLATE 33
Detail, Eve and a broken
Tree of Knowledge in the
Grotto of Paradise Lost
at the Grotto of the
Redemption, West Bend,
Iowa.

65

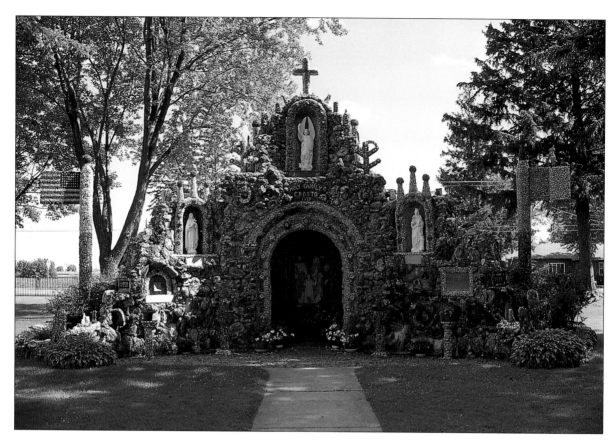

PLATE 34
Grotto of the Holy Family
at St. Joseph's Ridge,
Wisconsin. Designed by
Paul Dobberstein and
built by Frank Donsky,
the grotto shows the
influence of Dickeyville's
grotto in its paired flags,
dedicatory dates, and use
of colored glass.

66

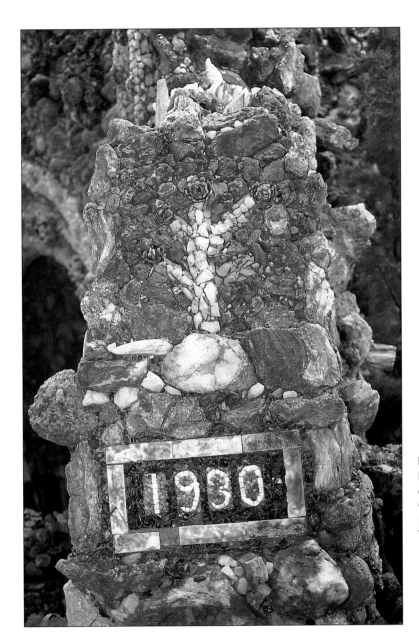

PLATE 35
Detail, glass rosettes and
dedicatory date at the
Grotto of the Holy
Family, St. Joseph's Ridge,
Wisconsin.

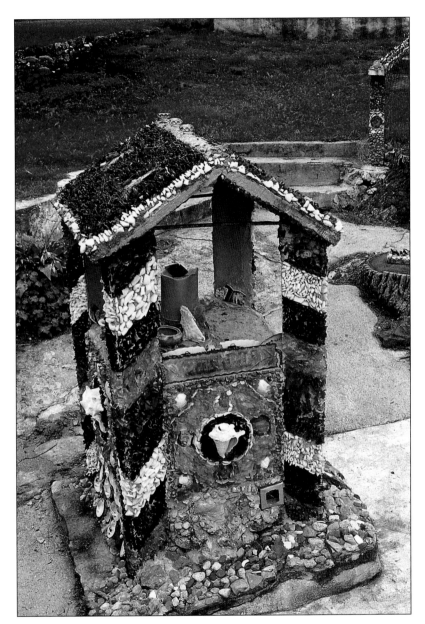

PLATE 37
Seven-foot-tall depiction
of Jacob's Well at the
Wegner Grotto,
Cataract, Wisconsin.

P L A T E 3 8
Detail, entry portal to the
Wegner homestead,
Cataract, Wisconsin.

PLATE 39
Concrete-and-glass
replica of Paul and Ma-
thilda Wegner's fiftieth
wedding anniversary
cake, Wegner Grotto,
Cataract, Wisconsin.